Kickin it NEW SCHOOL

an adult coloring book of
illustrative tattoo designs

by

Tim Pangburn

The elements of these designs were selected through random processes, and there's no rhyme or reason to the overall structure, much like you and your DNA, and the reason your left leg is slightly shorter than your right. It's not my fault these creatures look like they do, it's the random generator system.

Don't blame me, blame science!

Copyright © 2019 Tim Pangburn

All rights reserved. This book or any portion thereof may not be reproduced or used in any manner whatsoever without the express written permission of the author.
I pity the fool who plagiarize my book.

ISBN: 9781097452019
First printing edition 2019
www.timpangburn.com
www.artmachineproductions.com

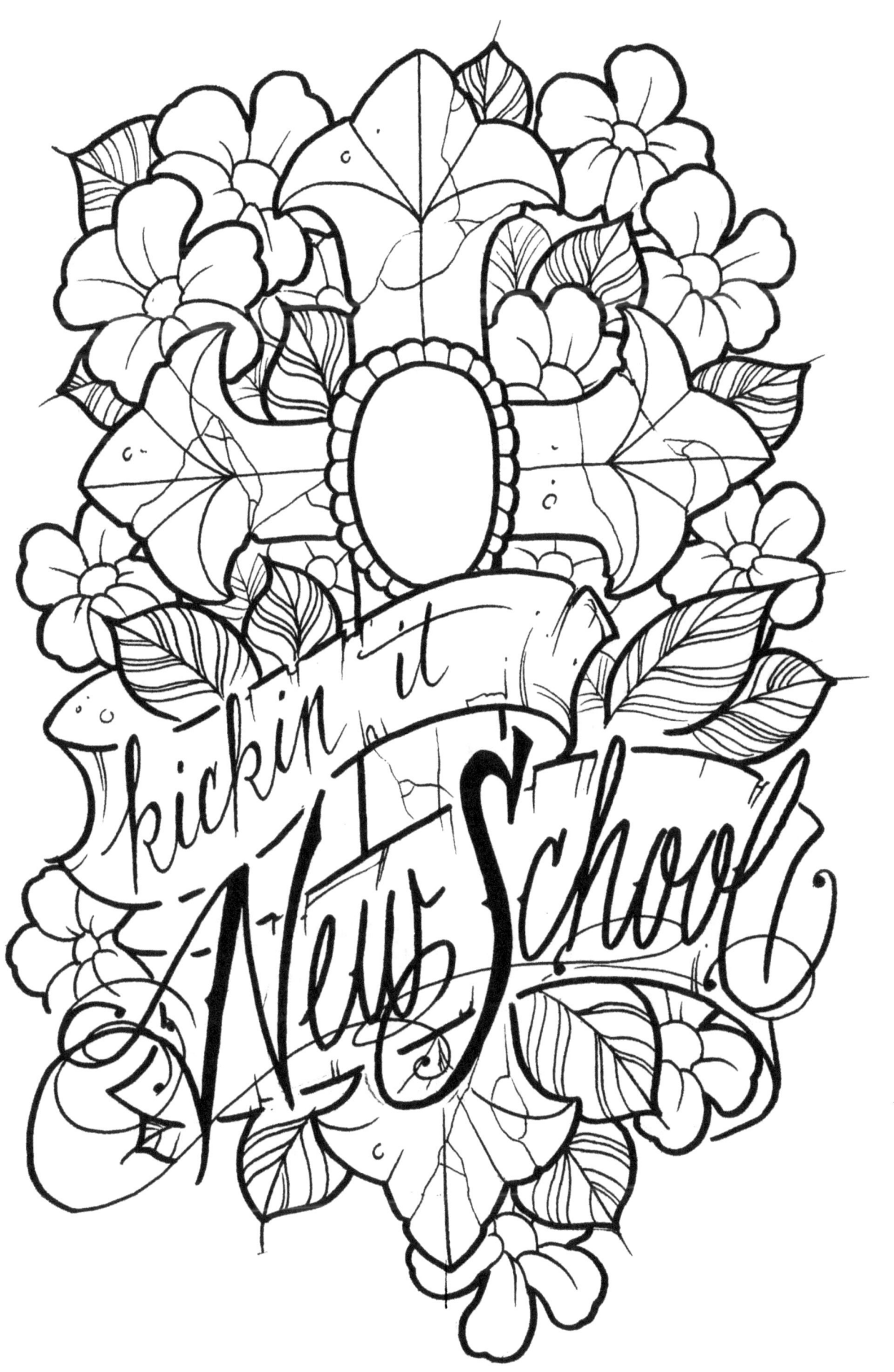

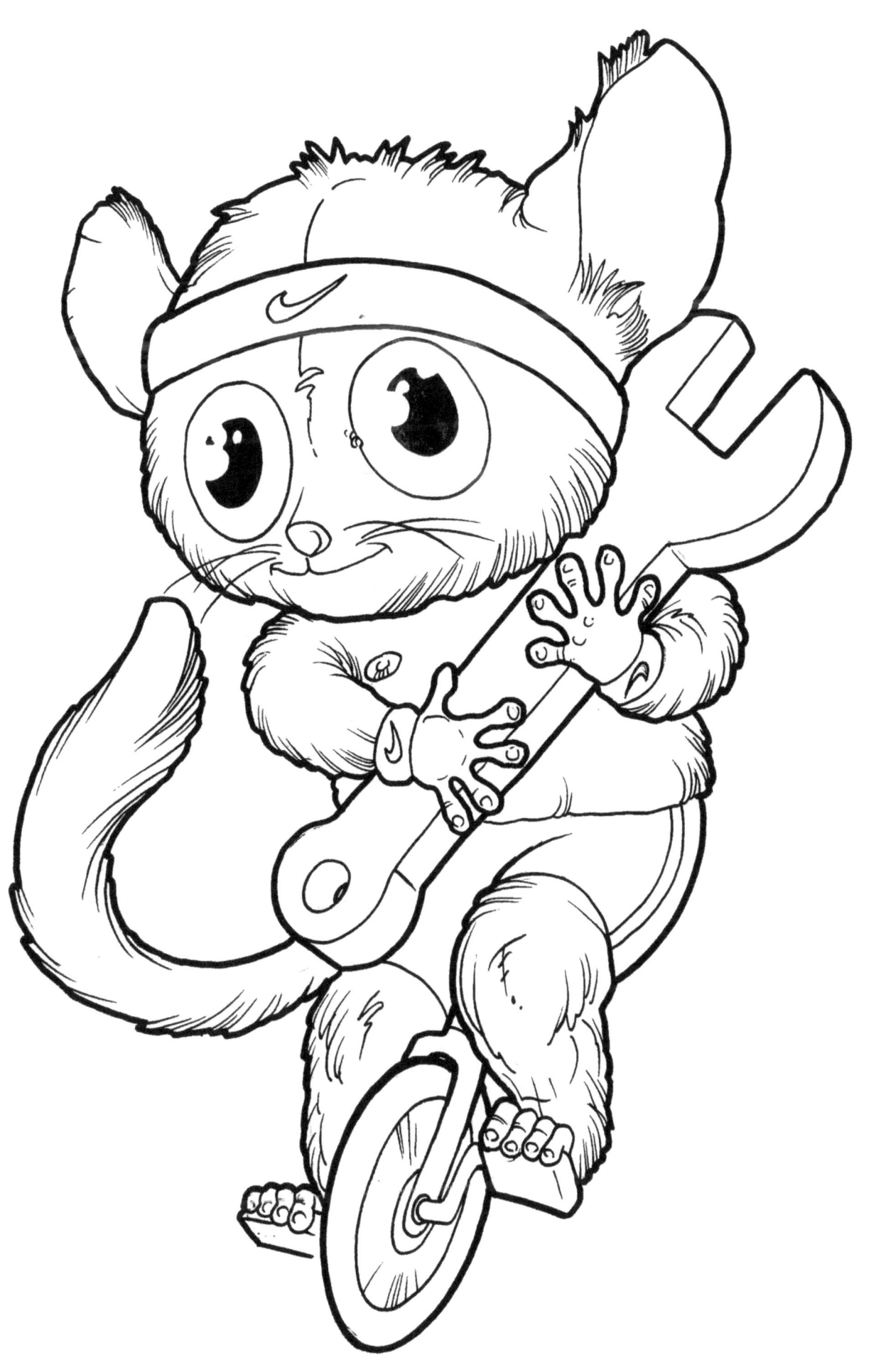

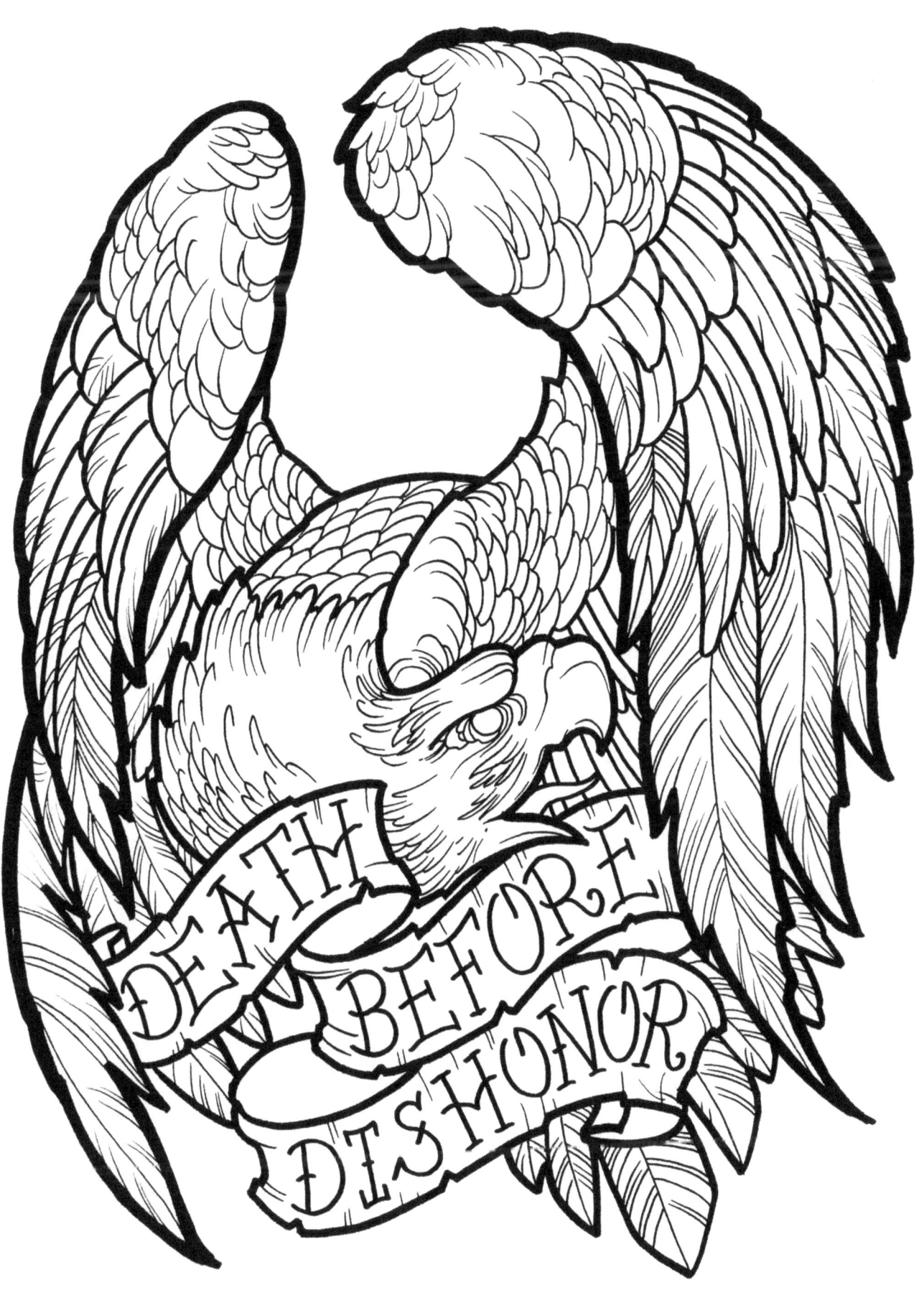

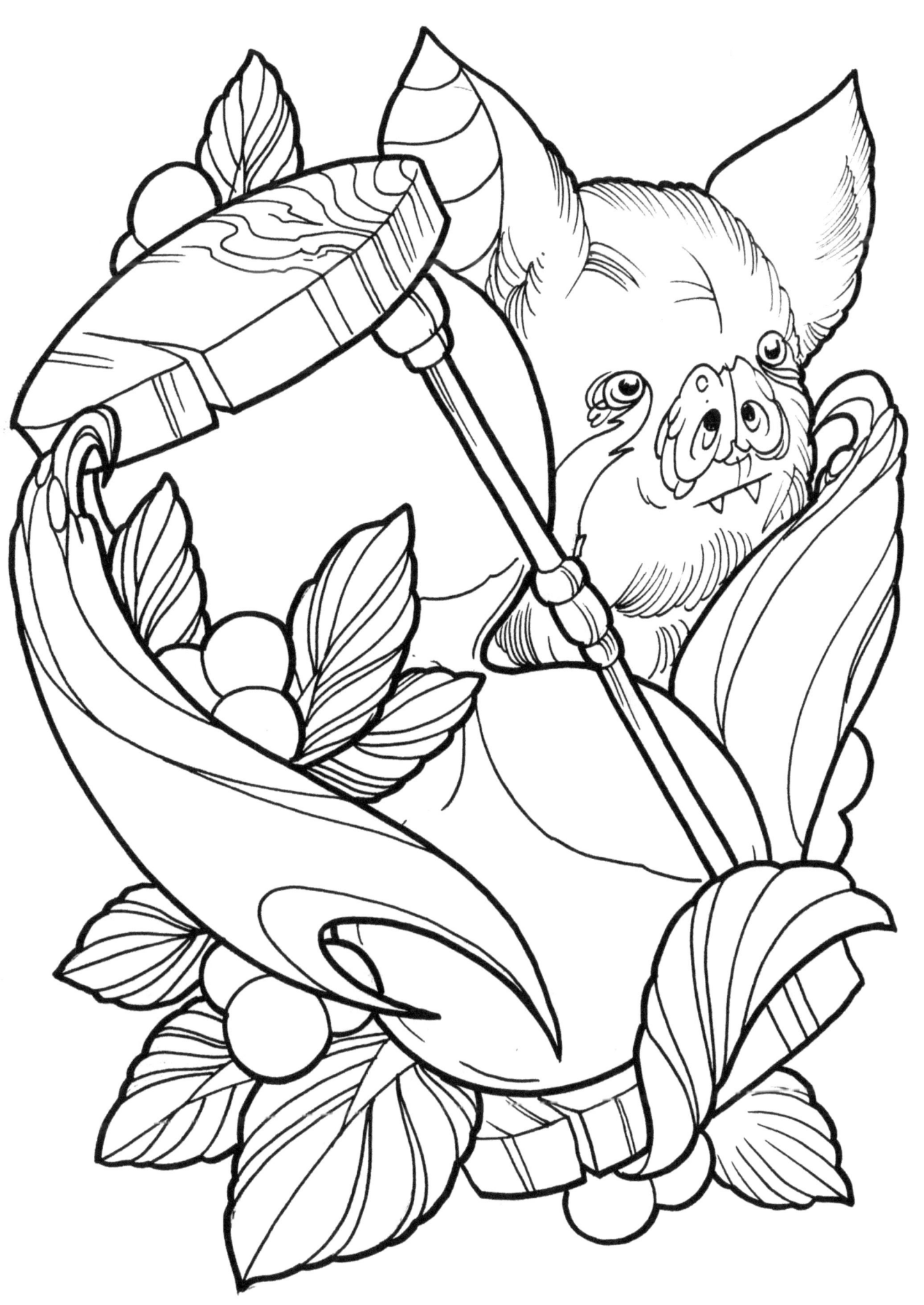

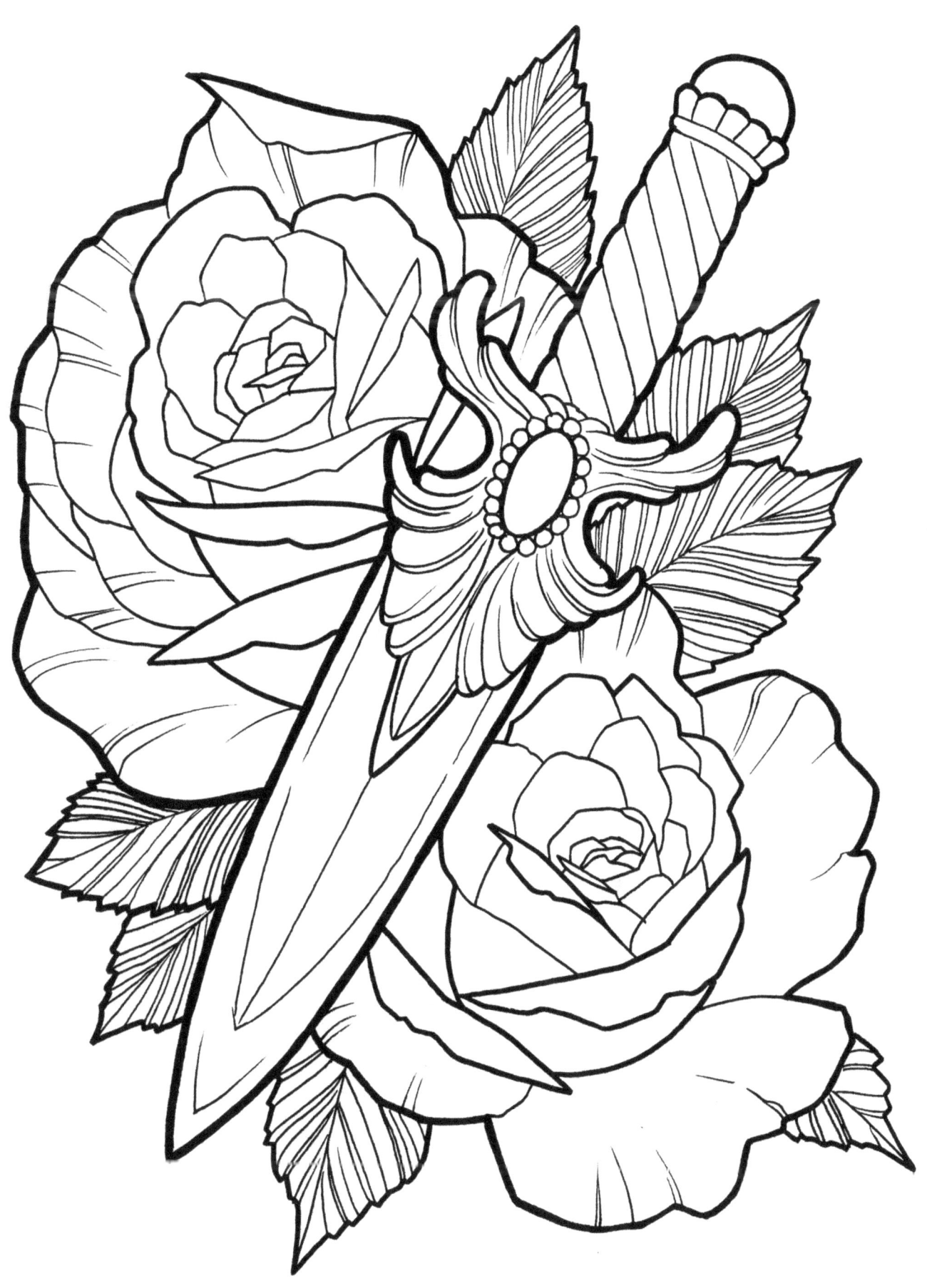

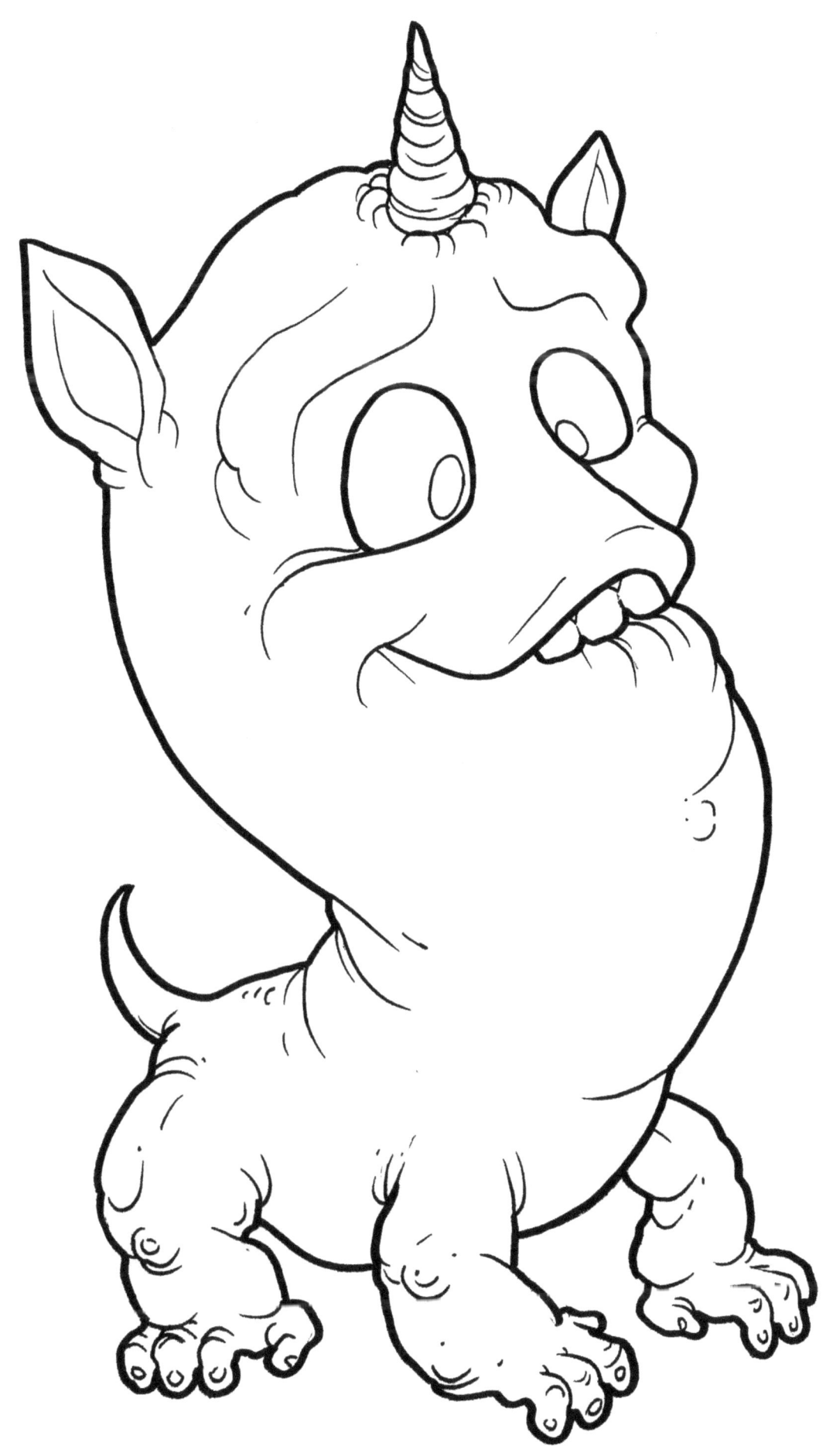

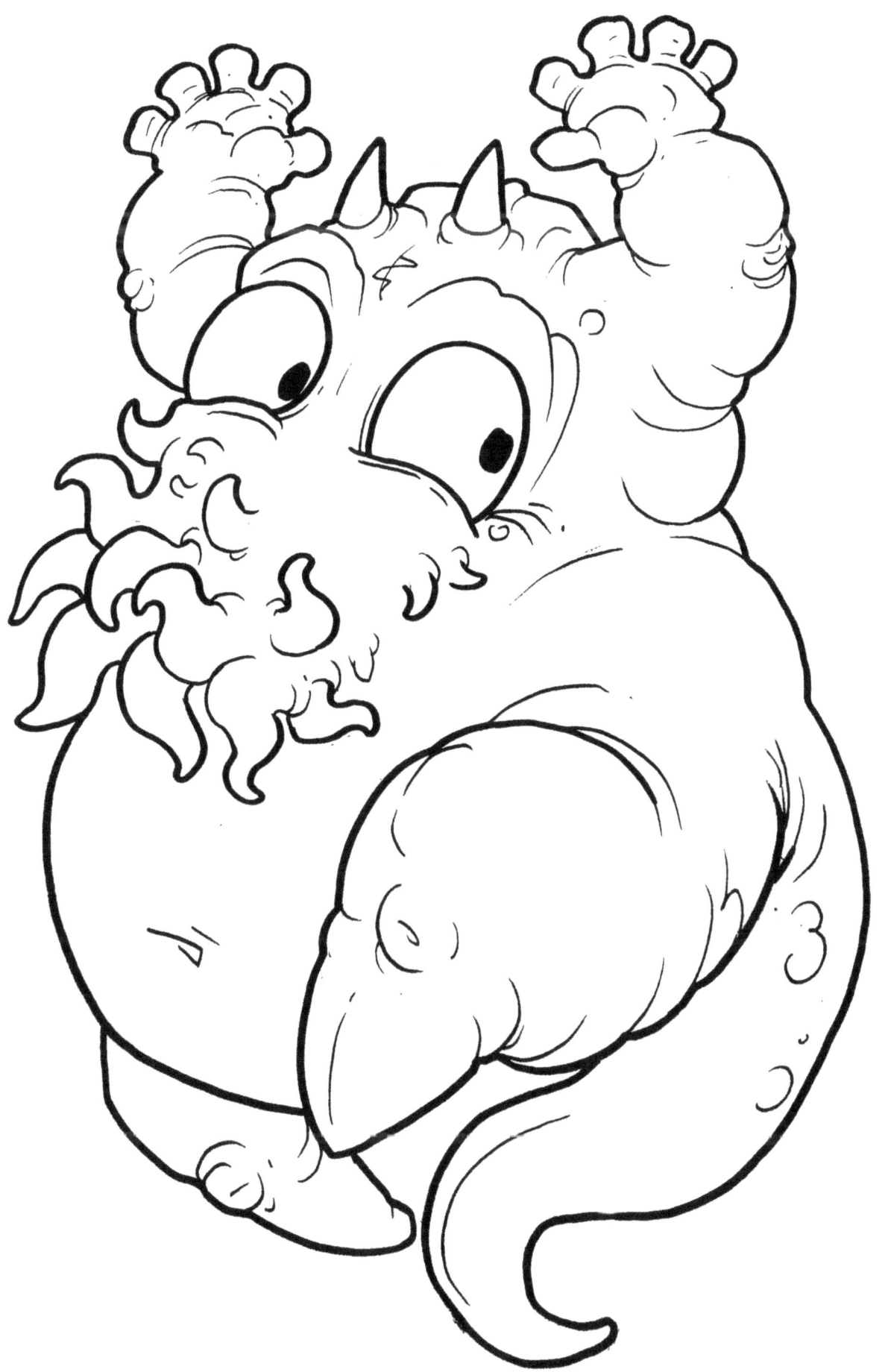

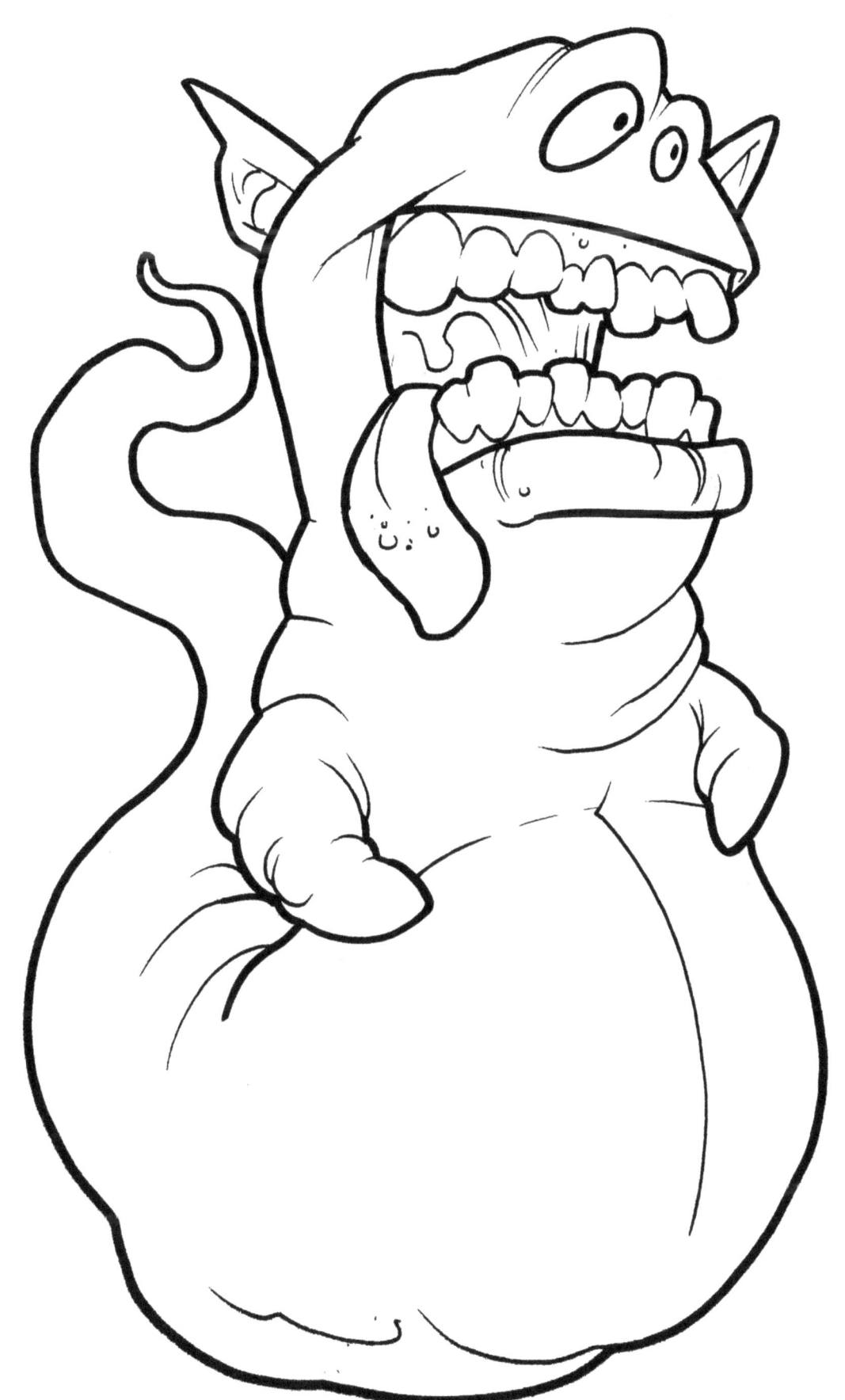

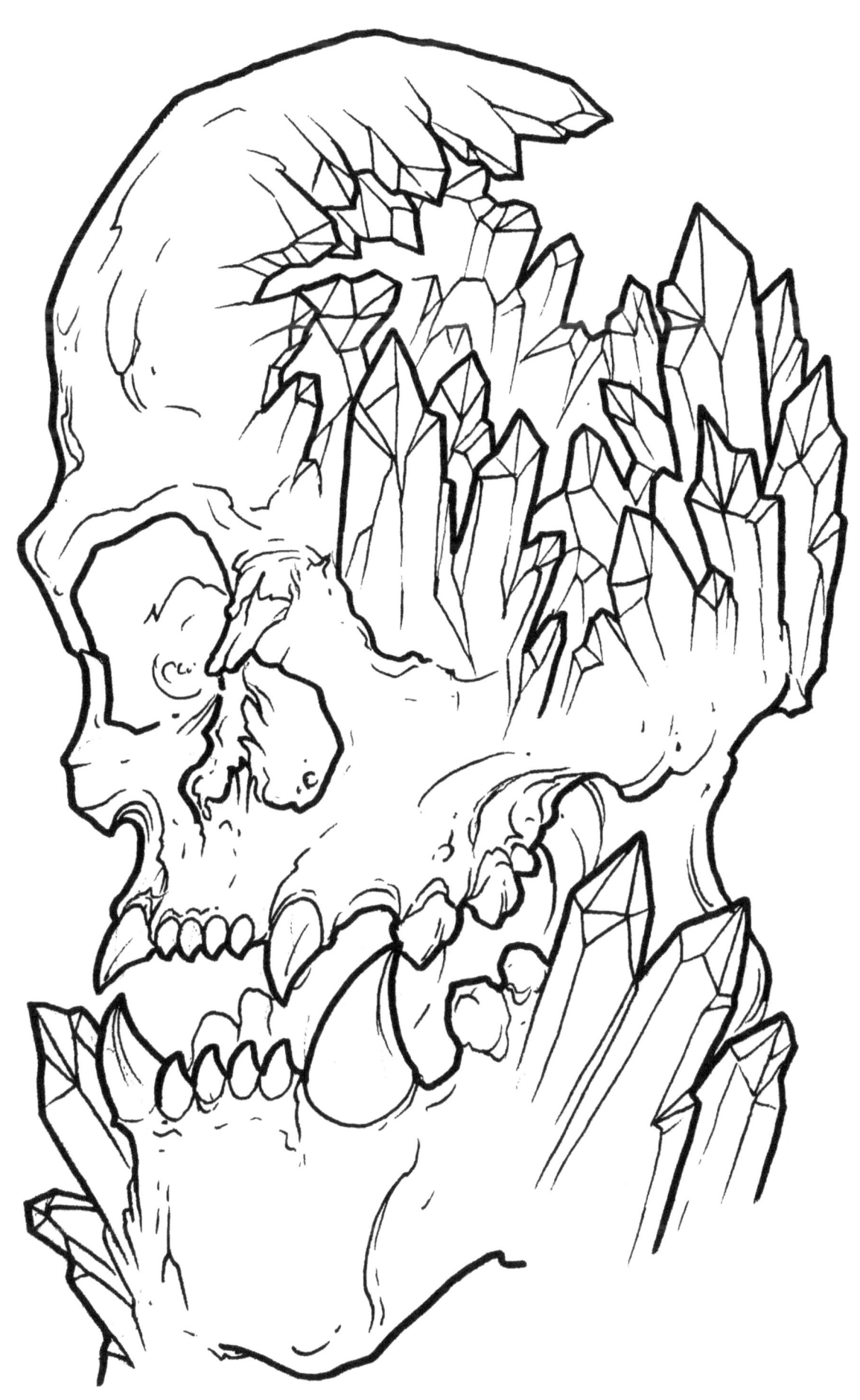

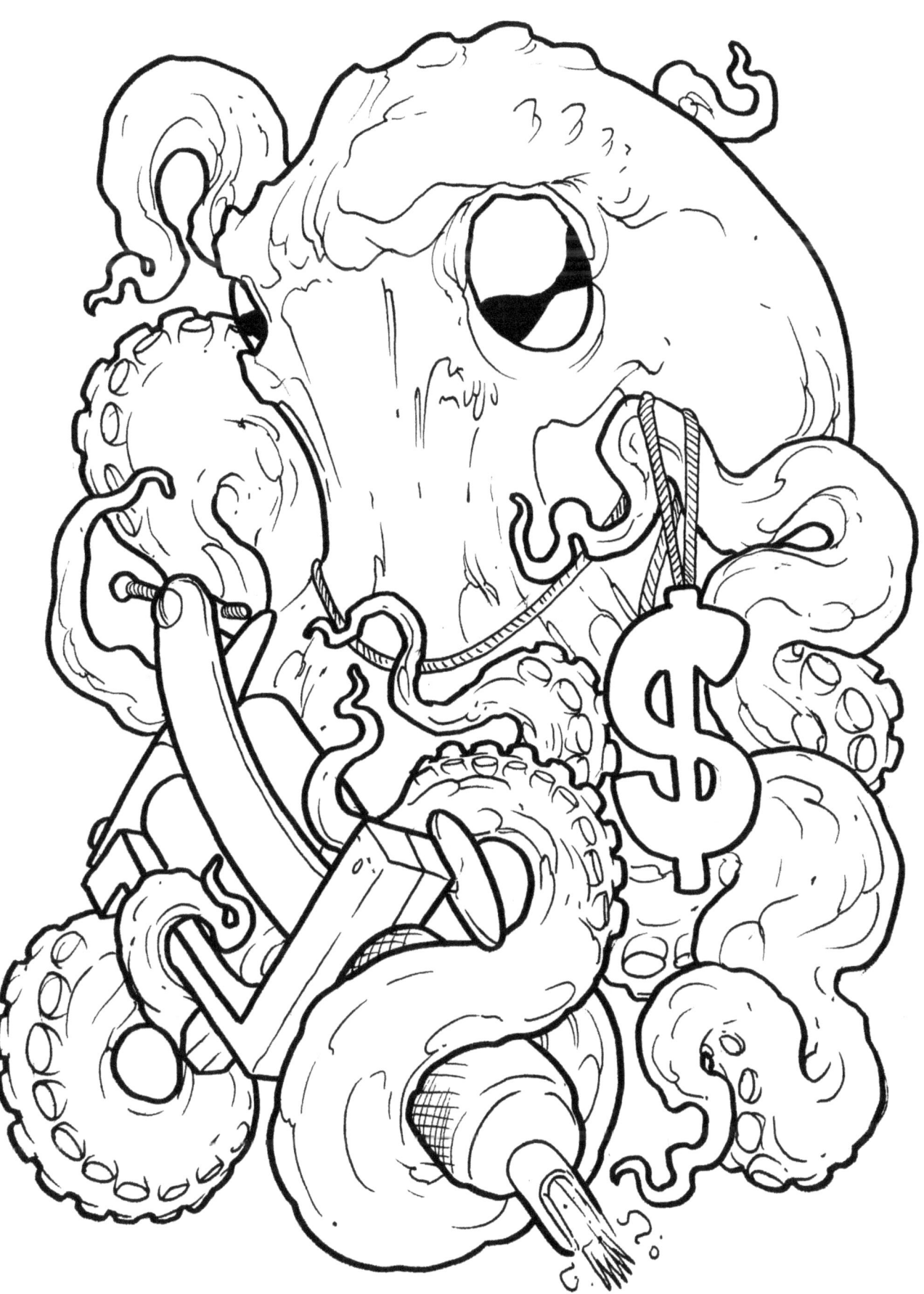

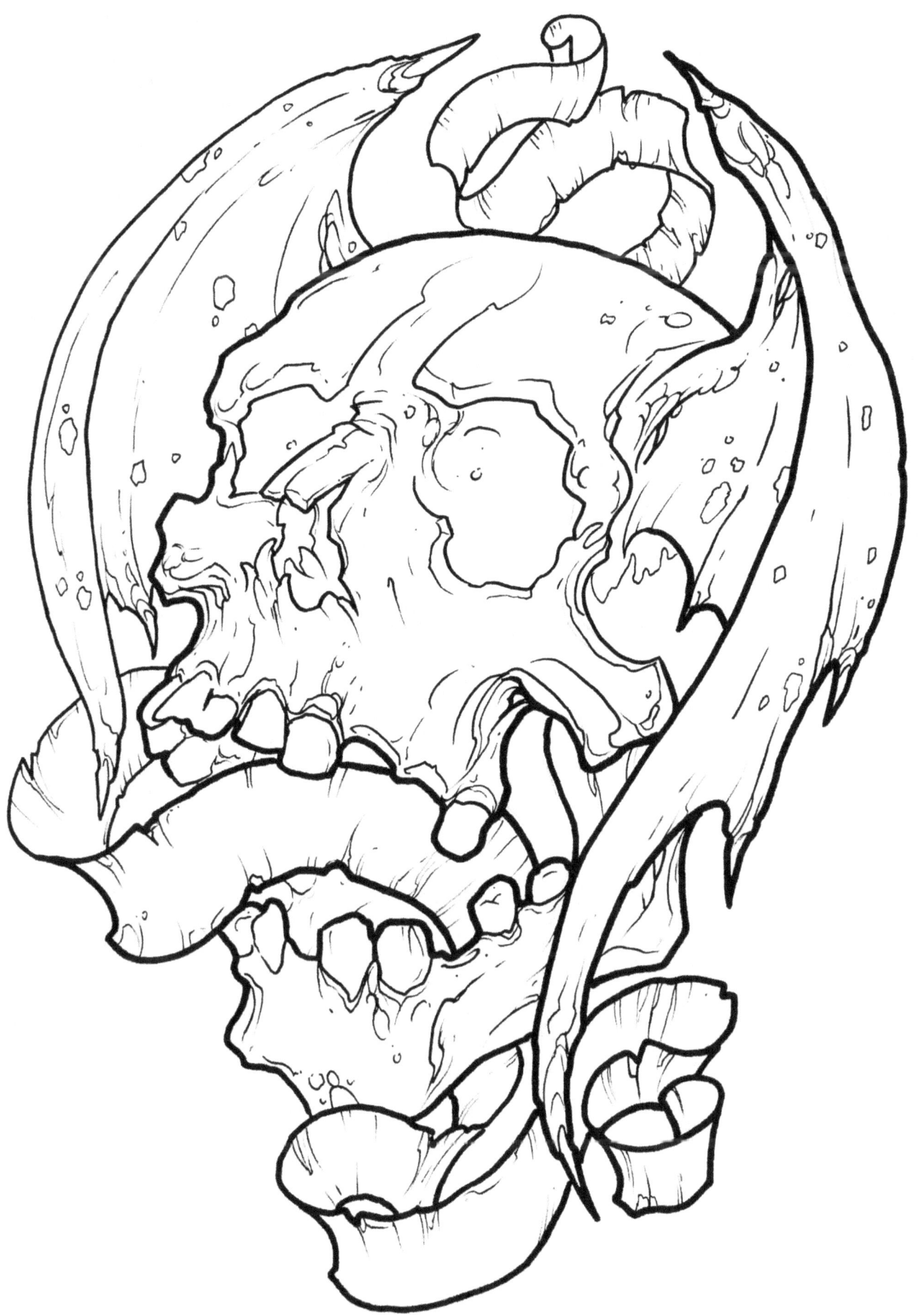

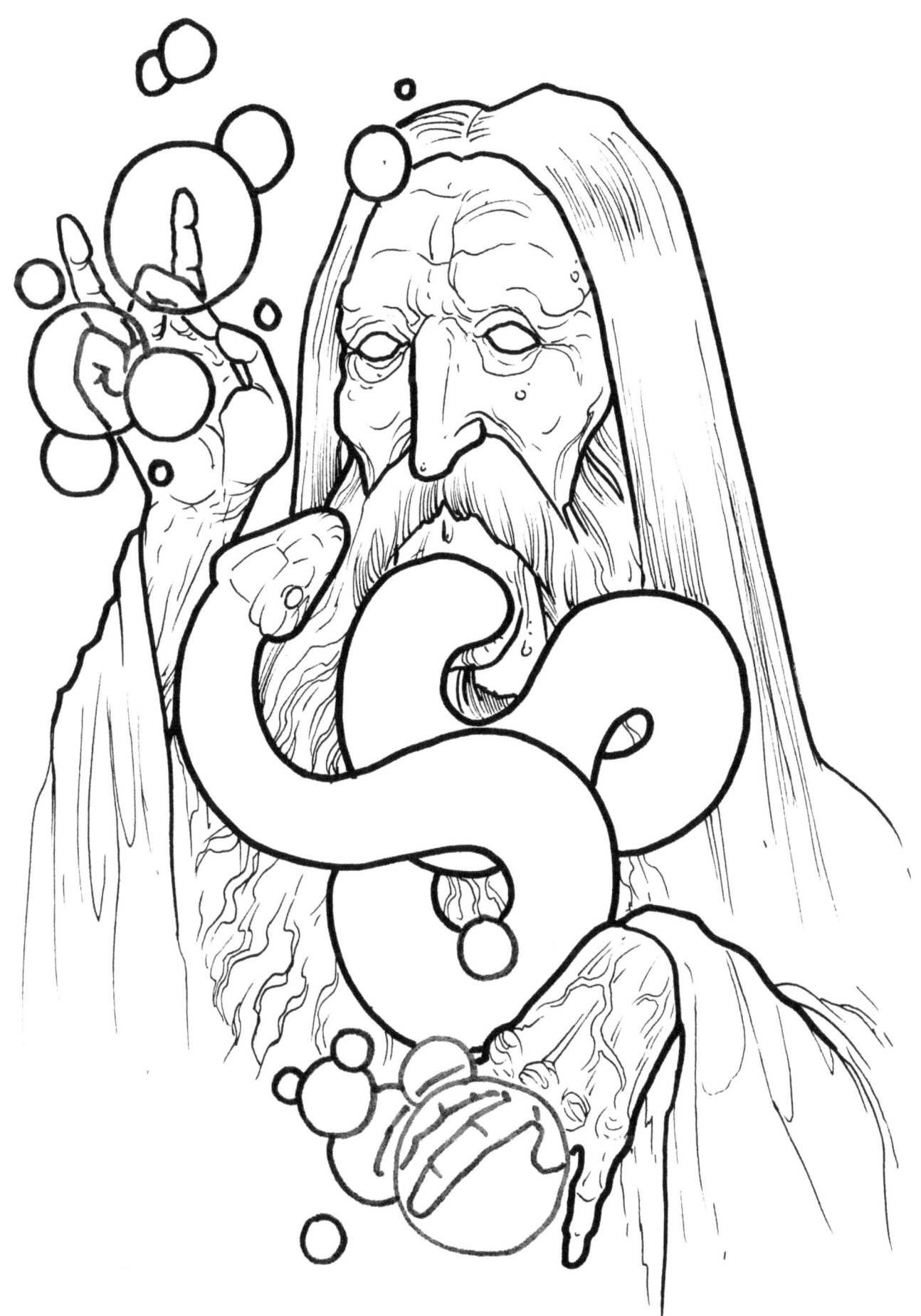

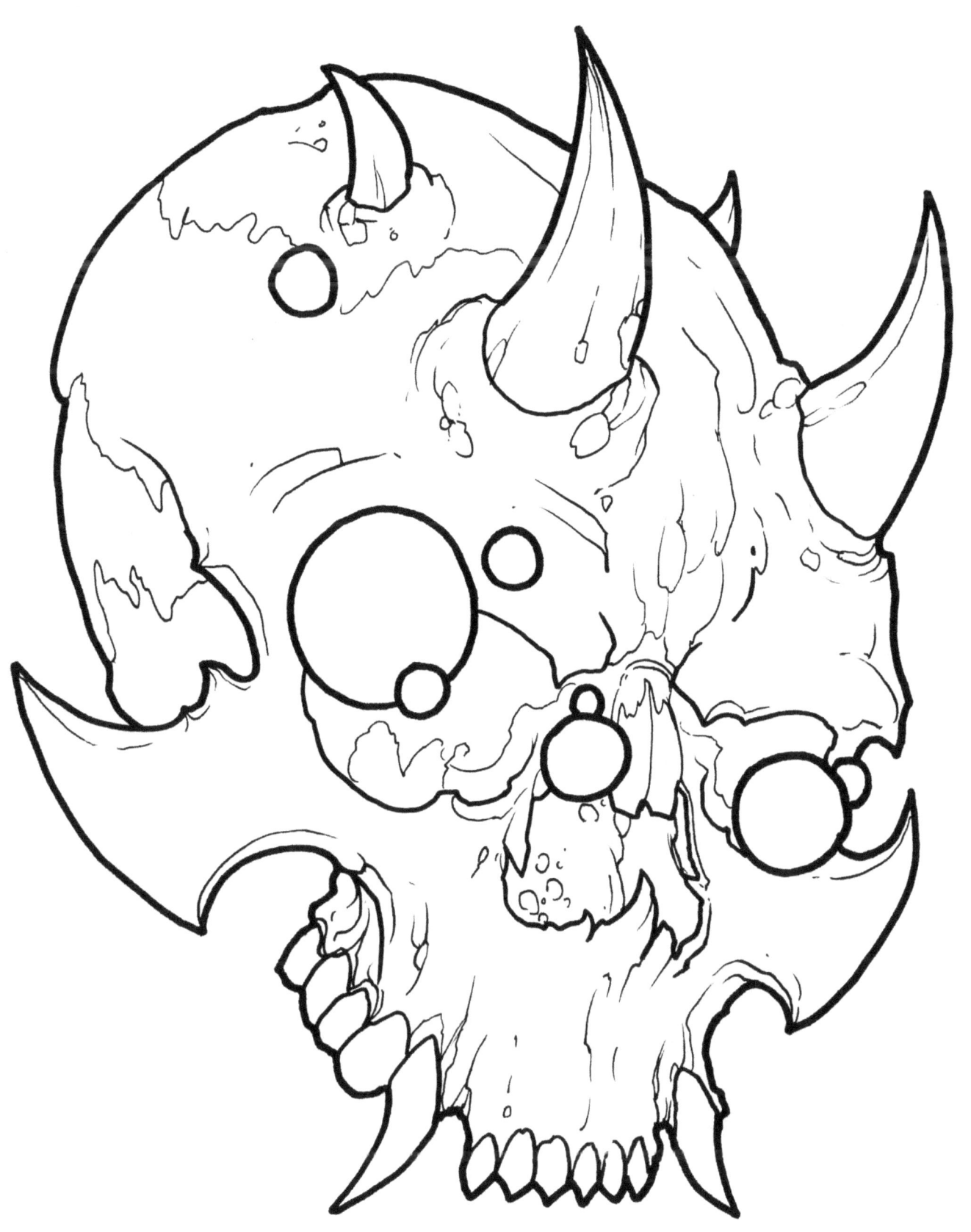

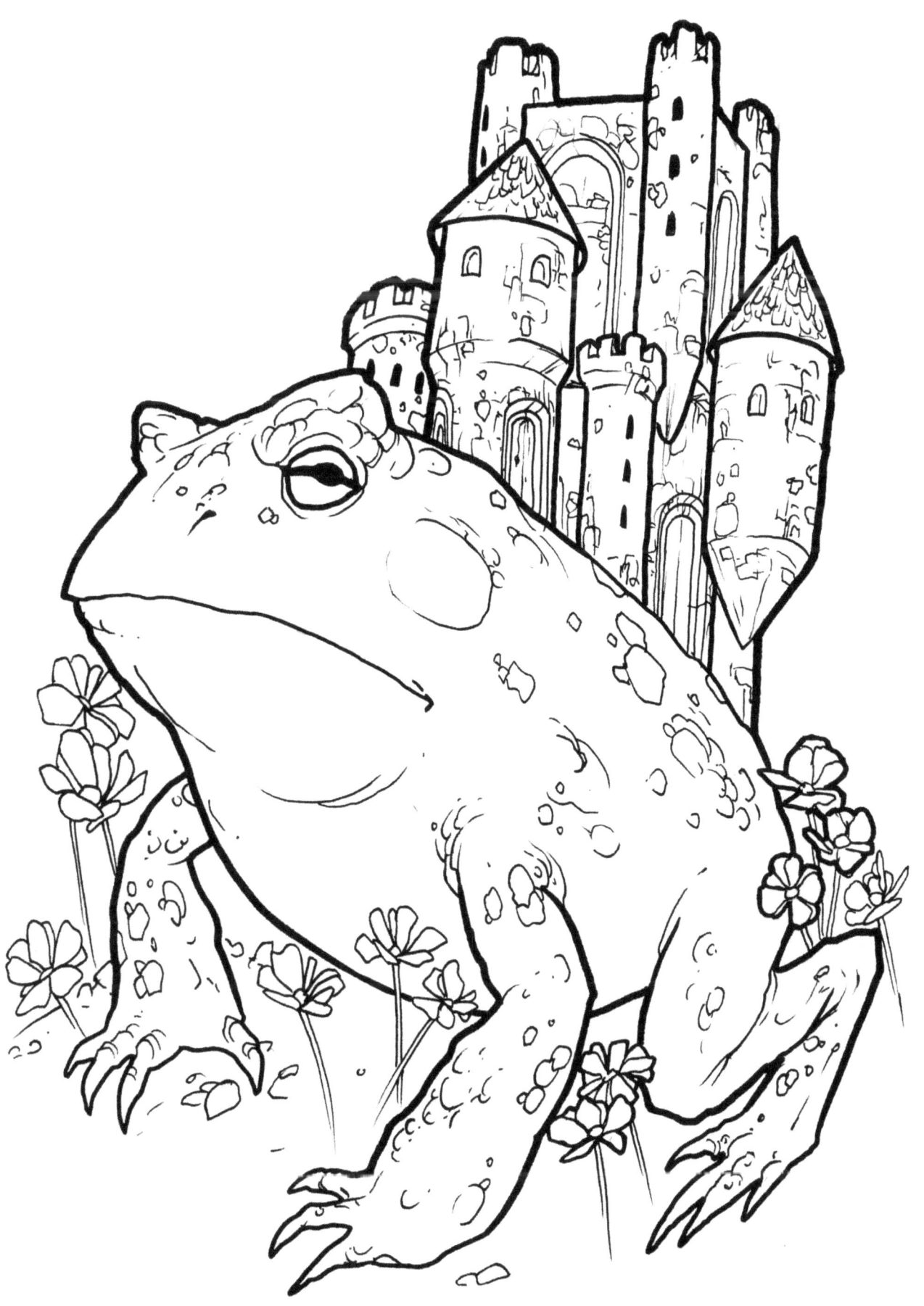

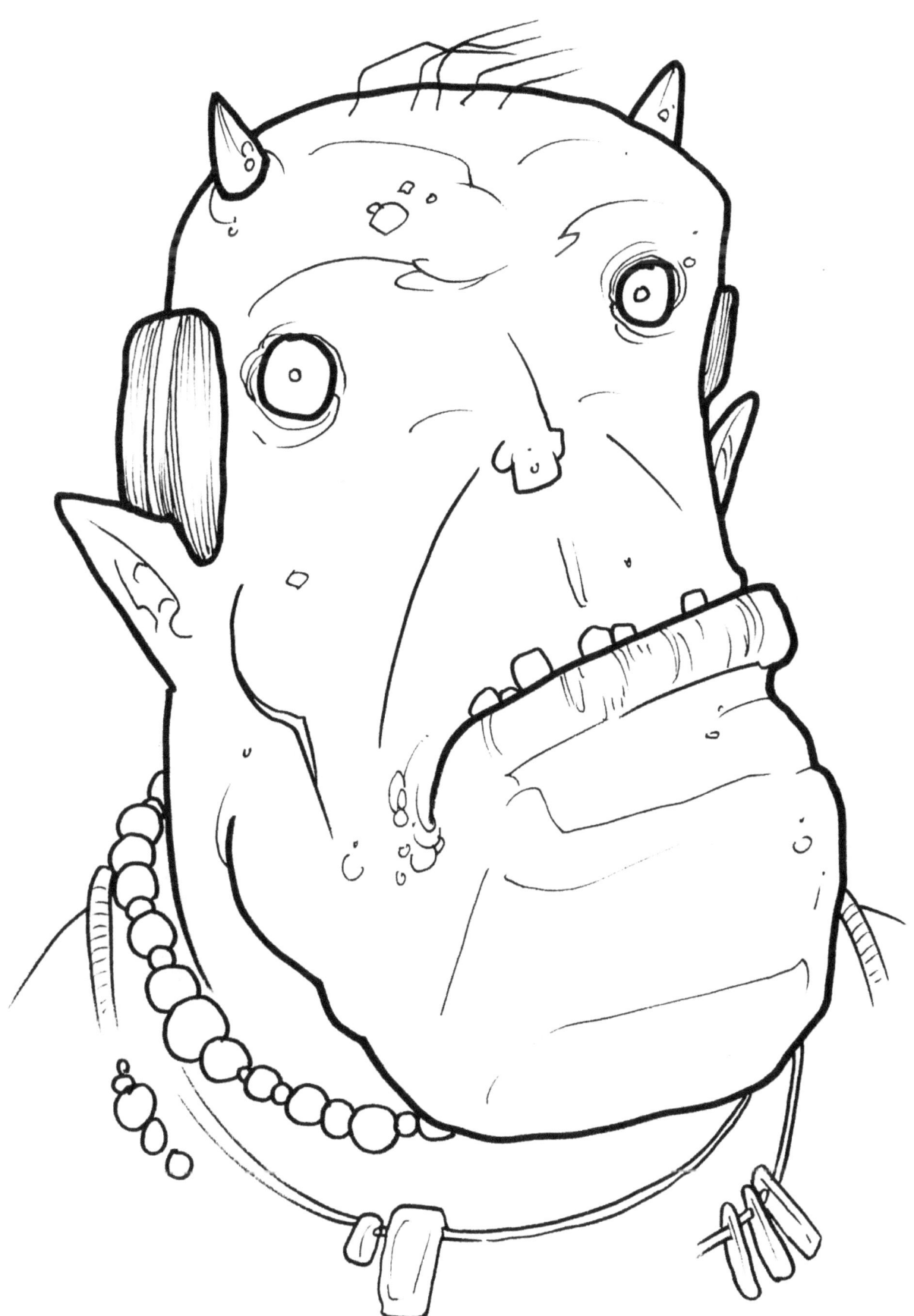

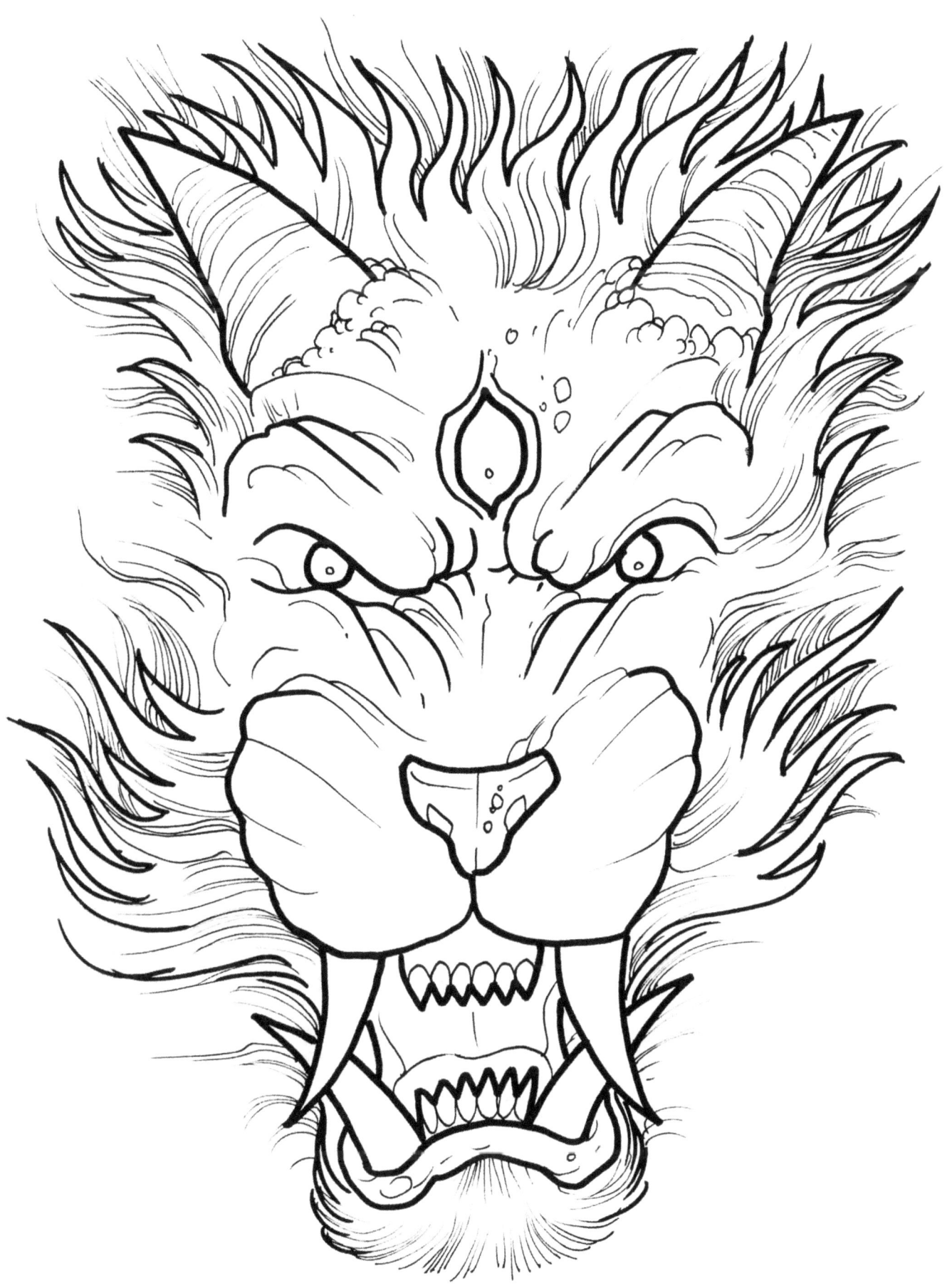

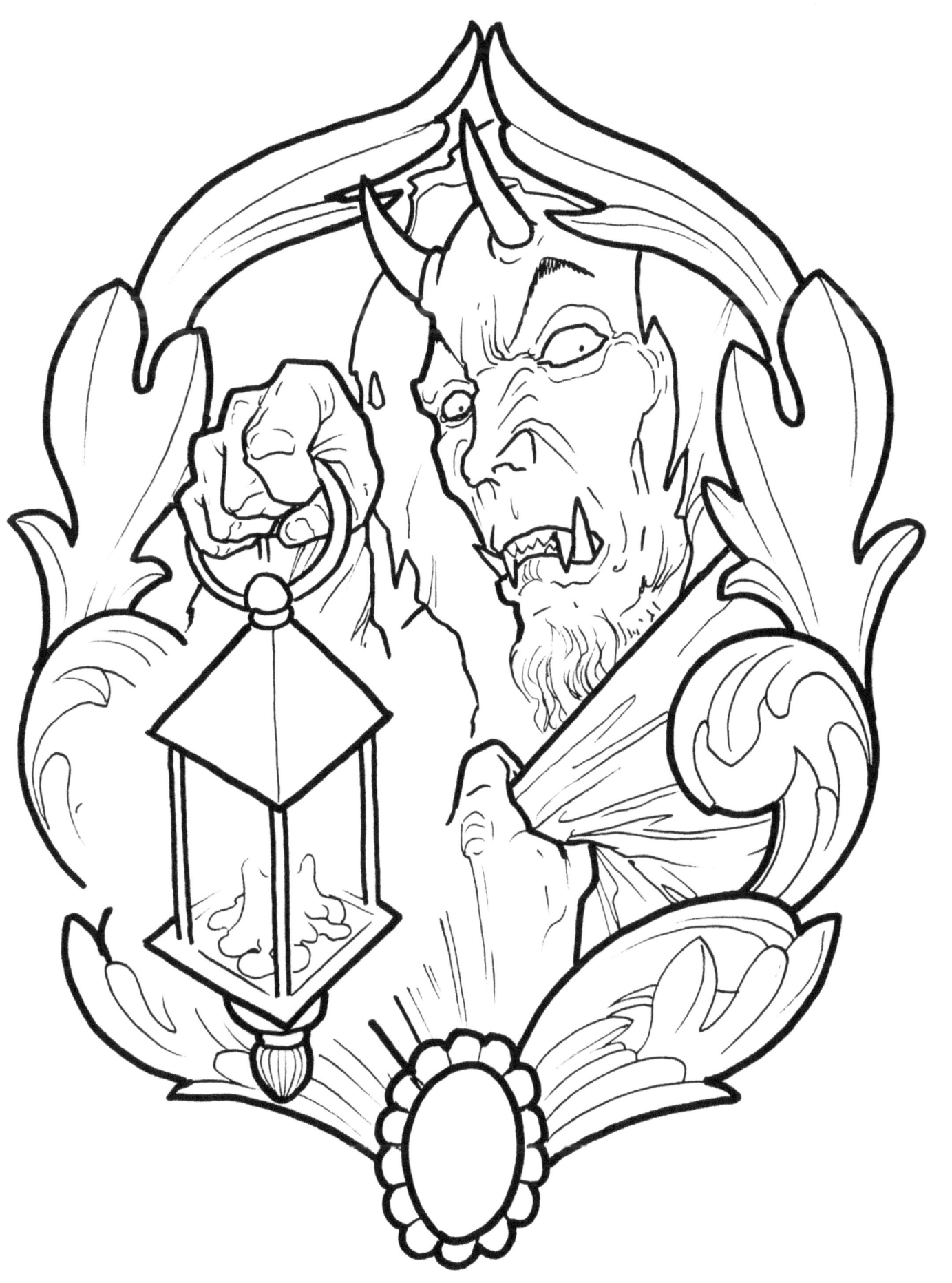

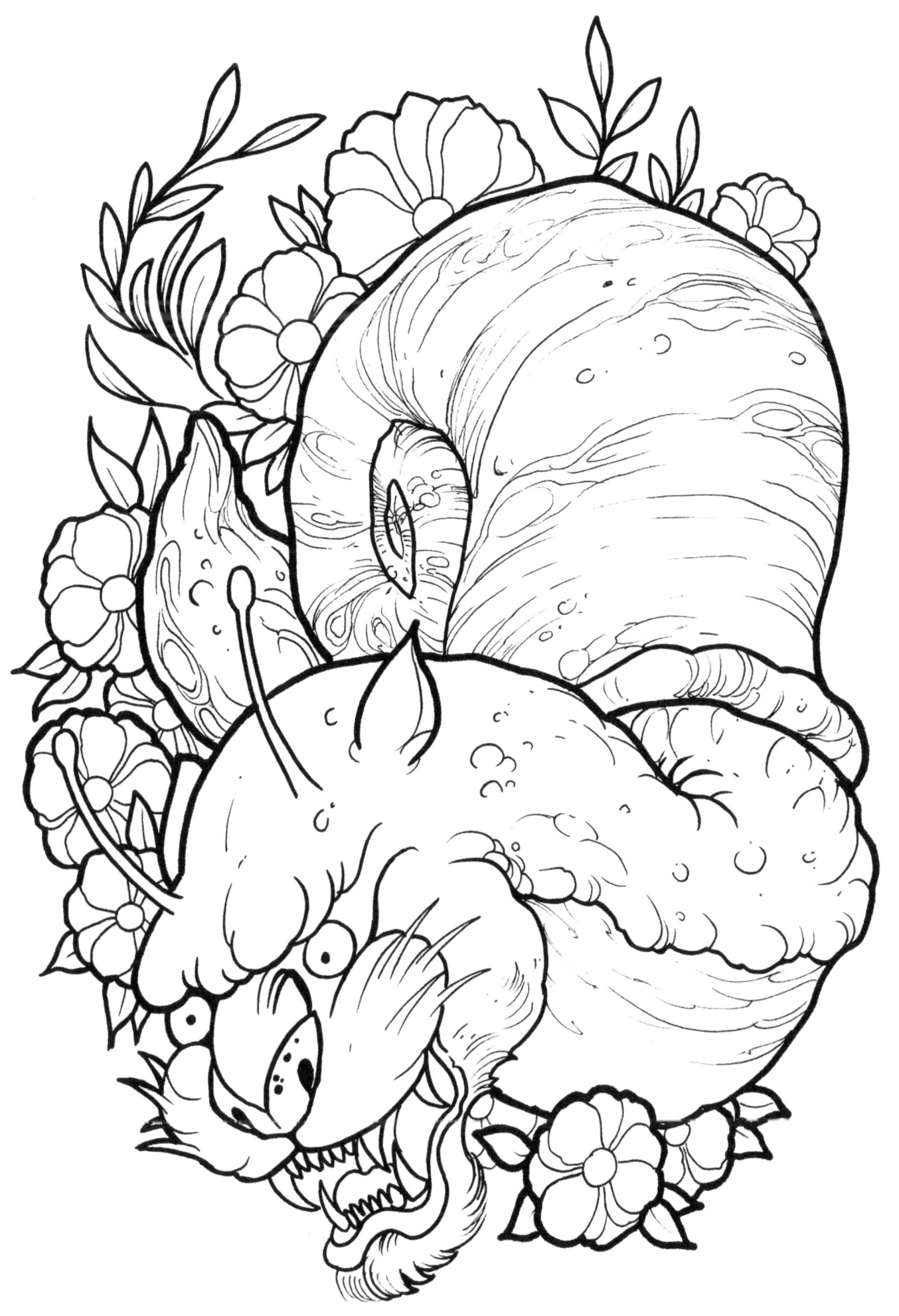

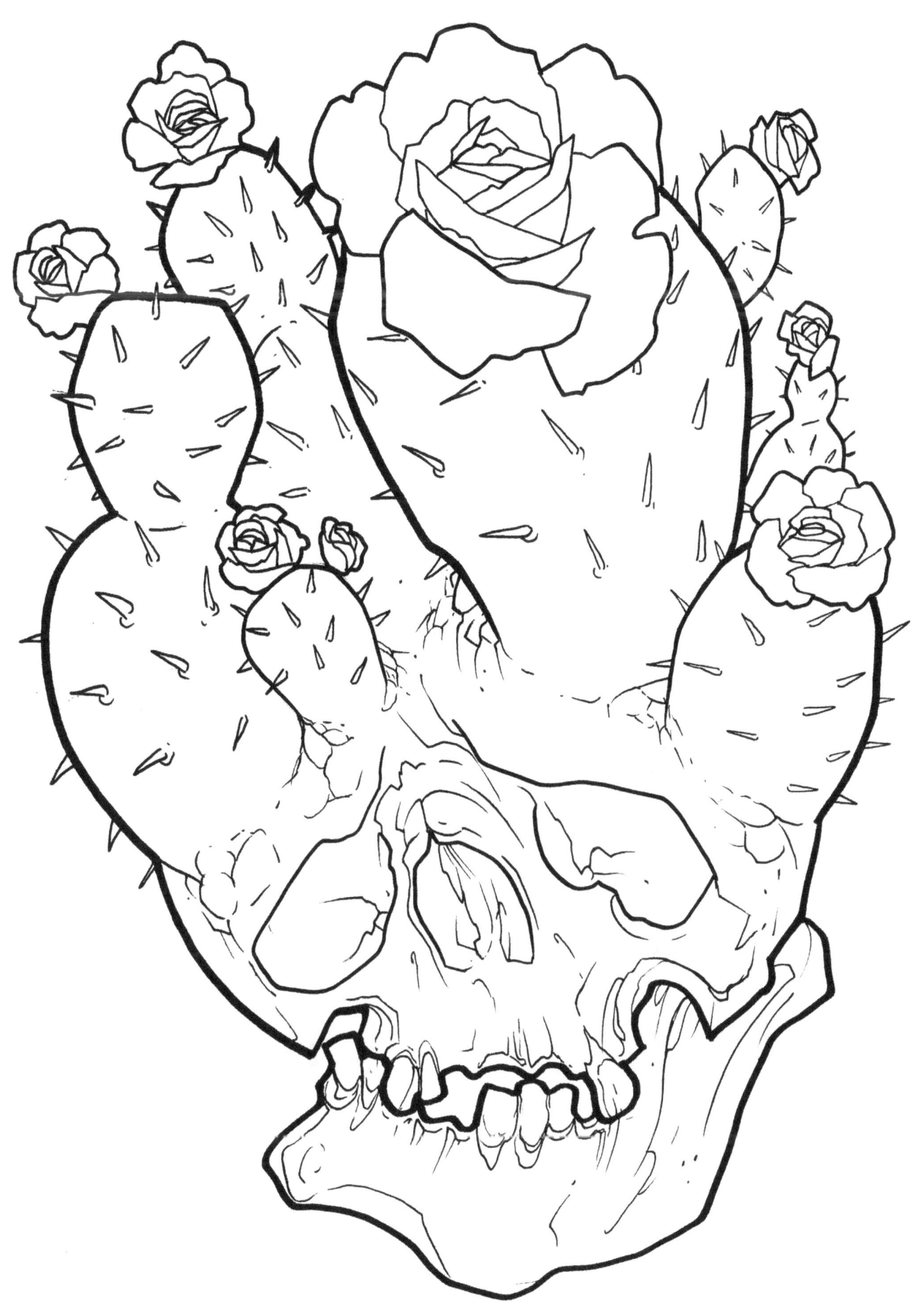

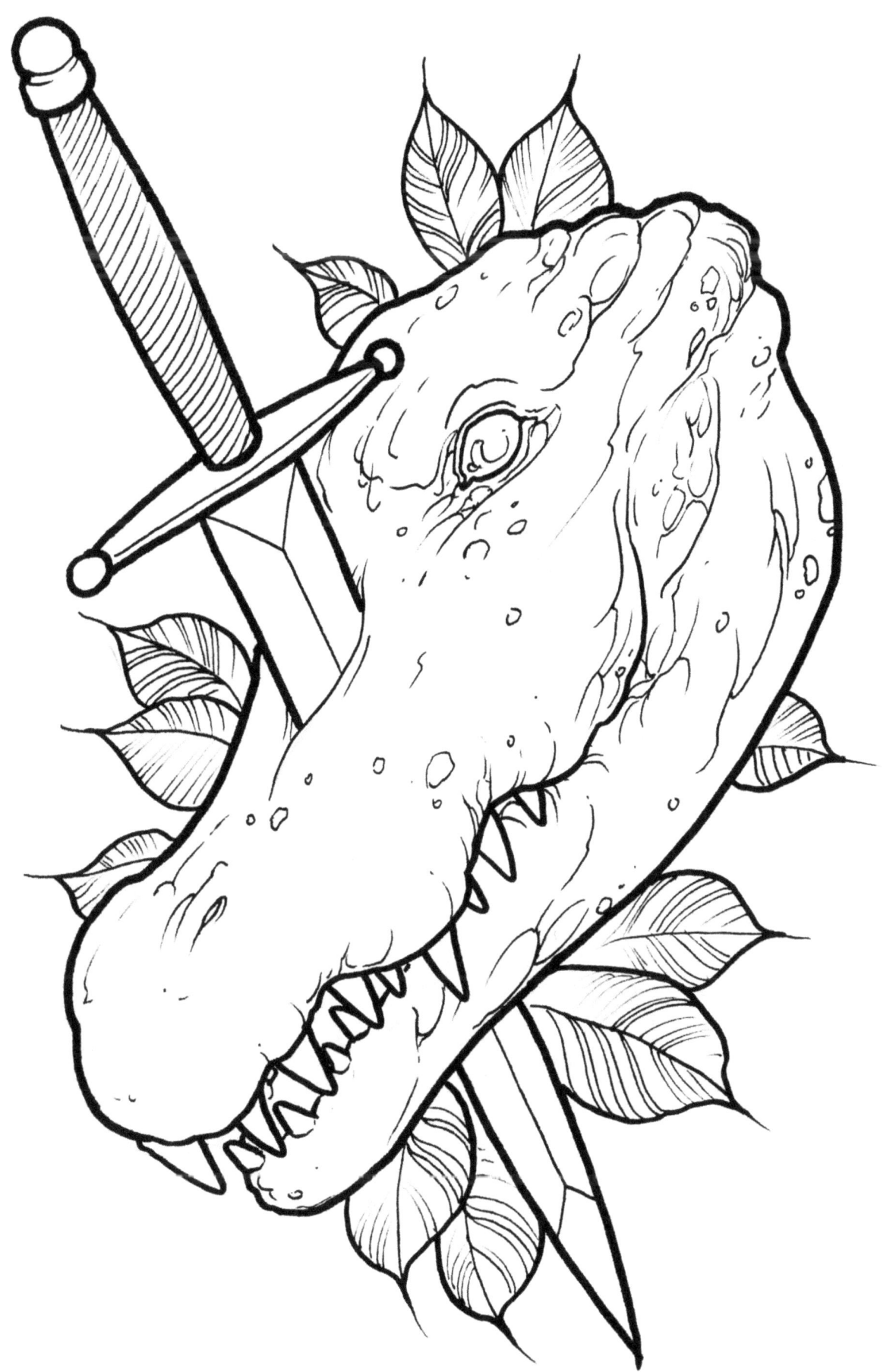

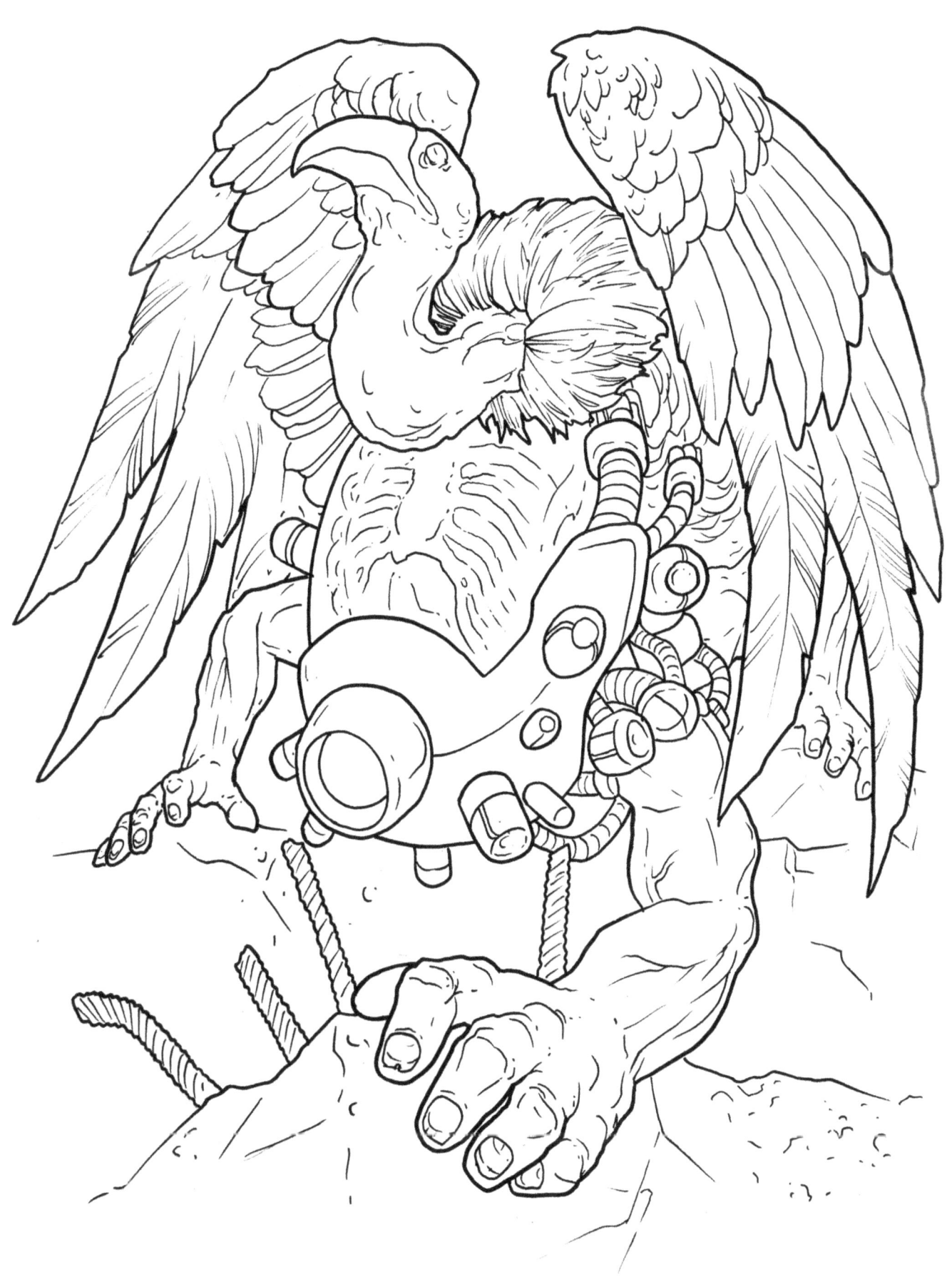

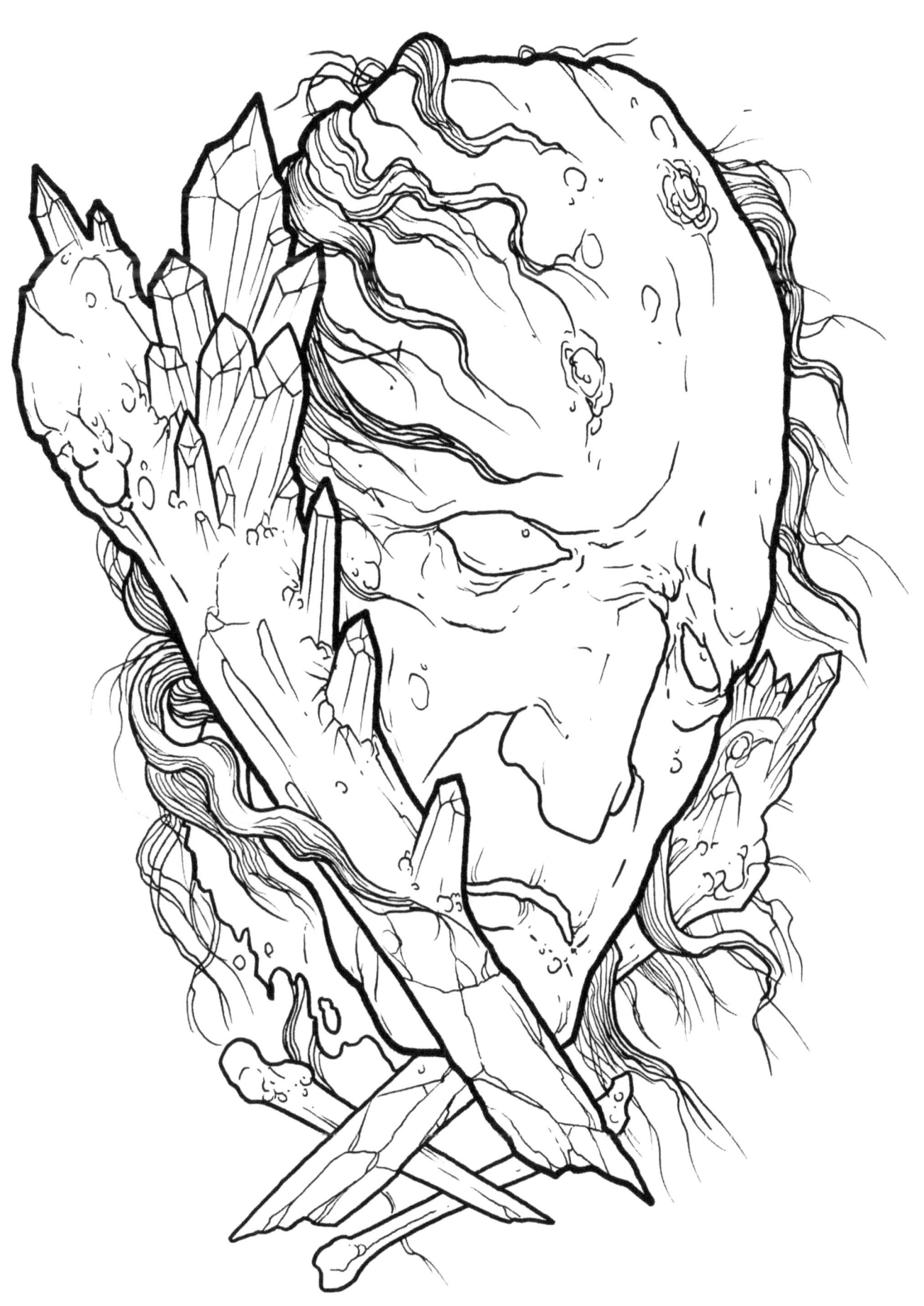

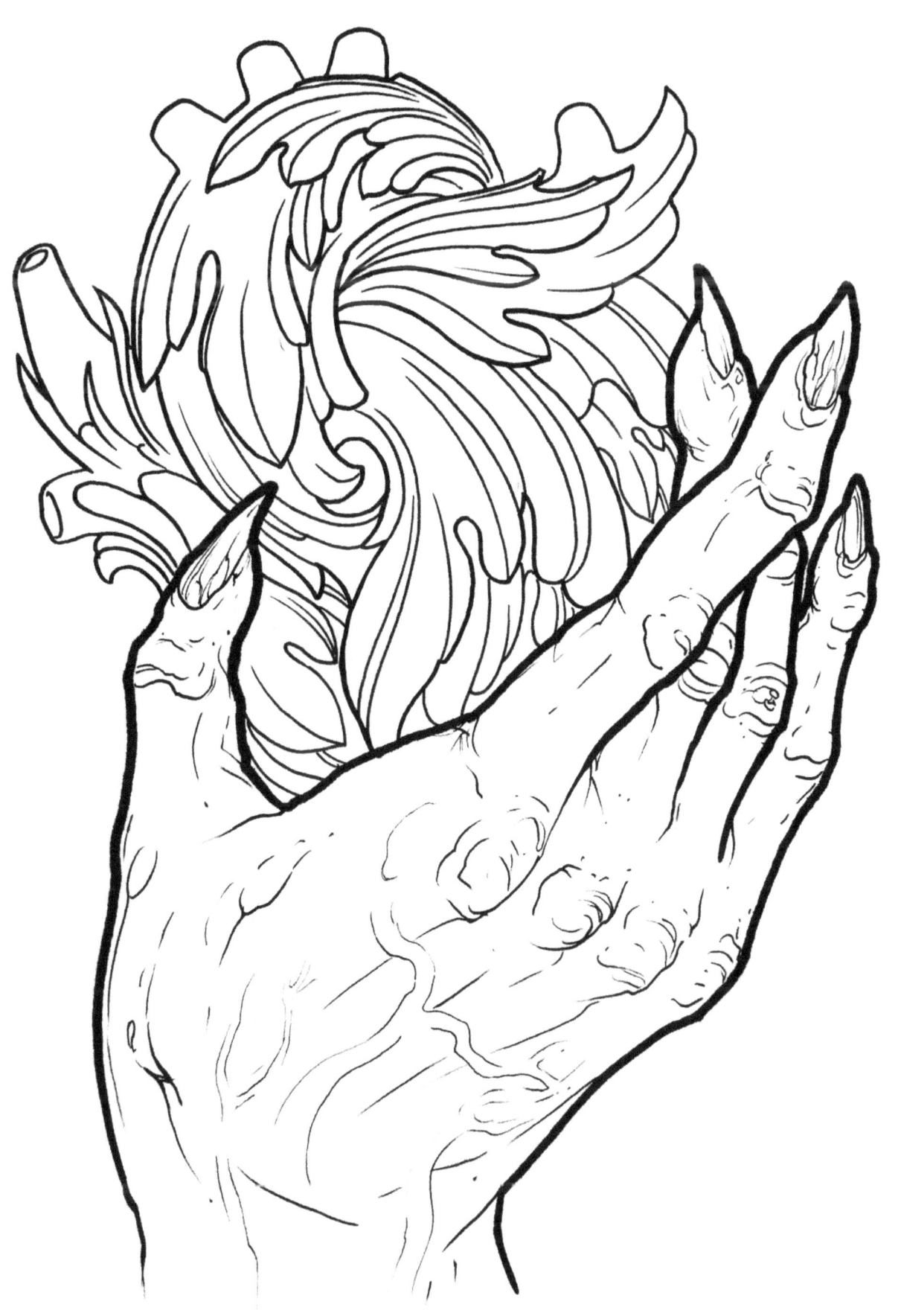

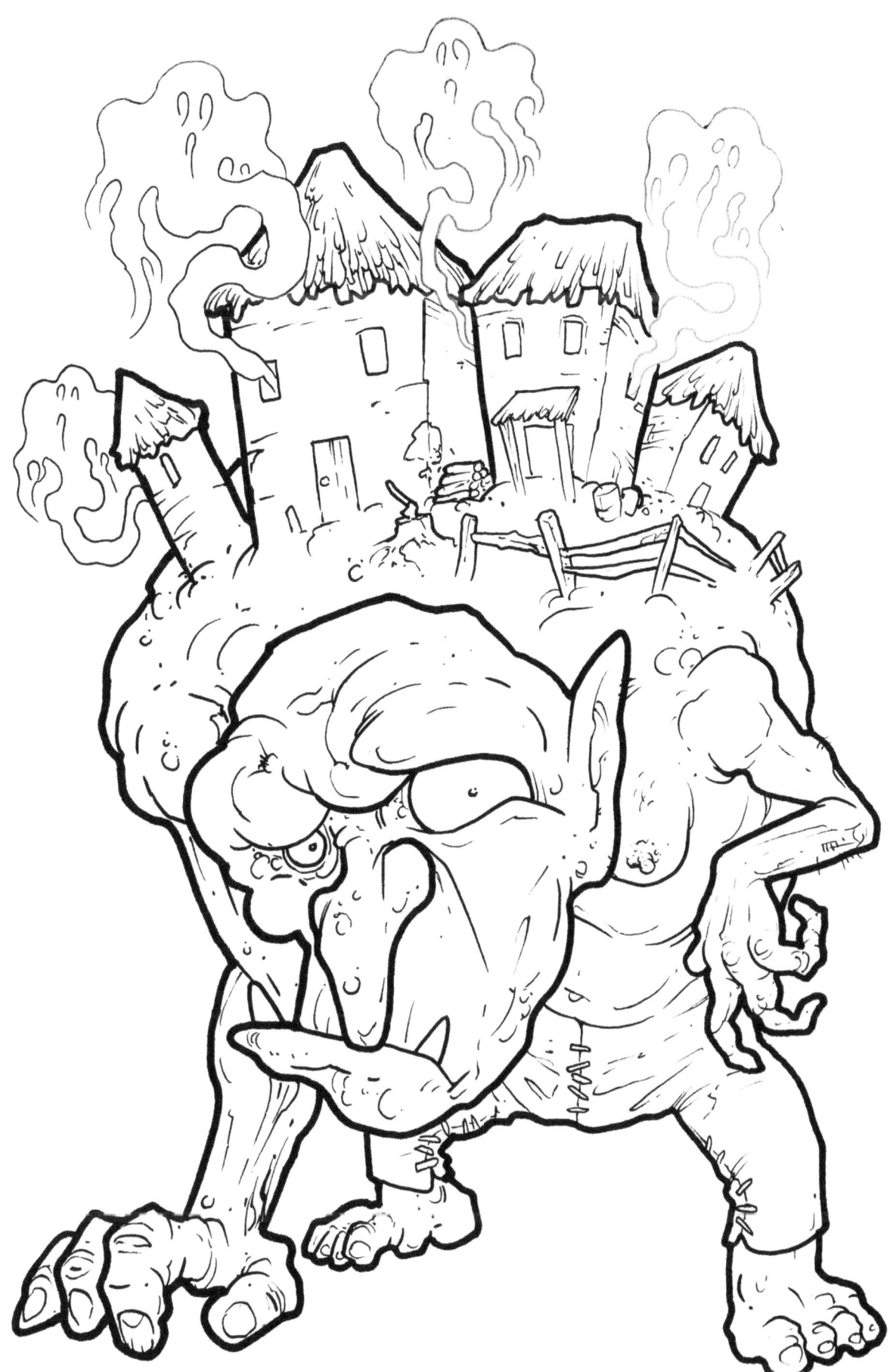

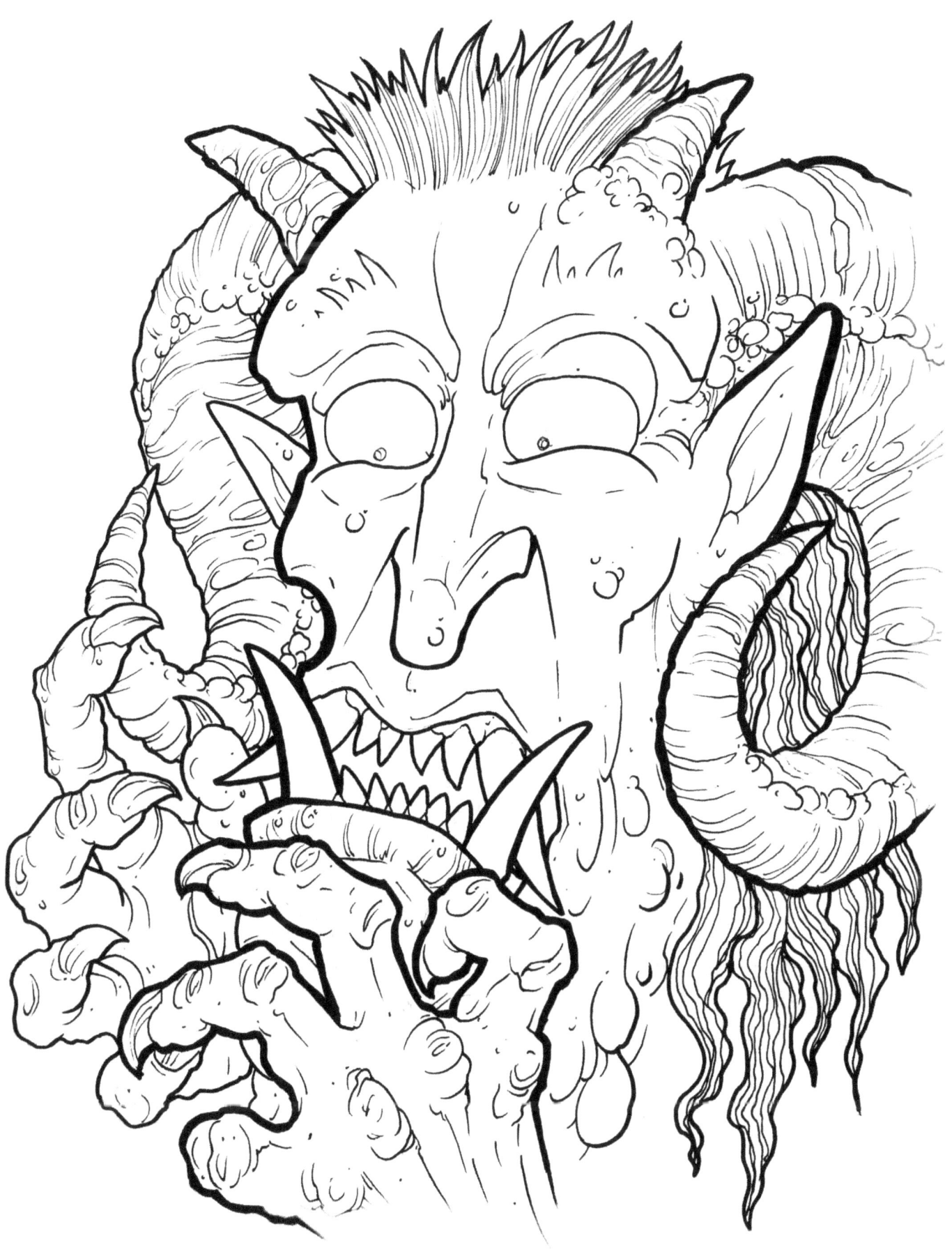

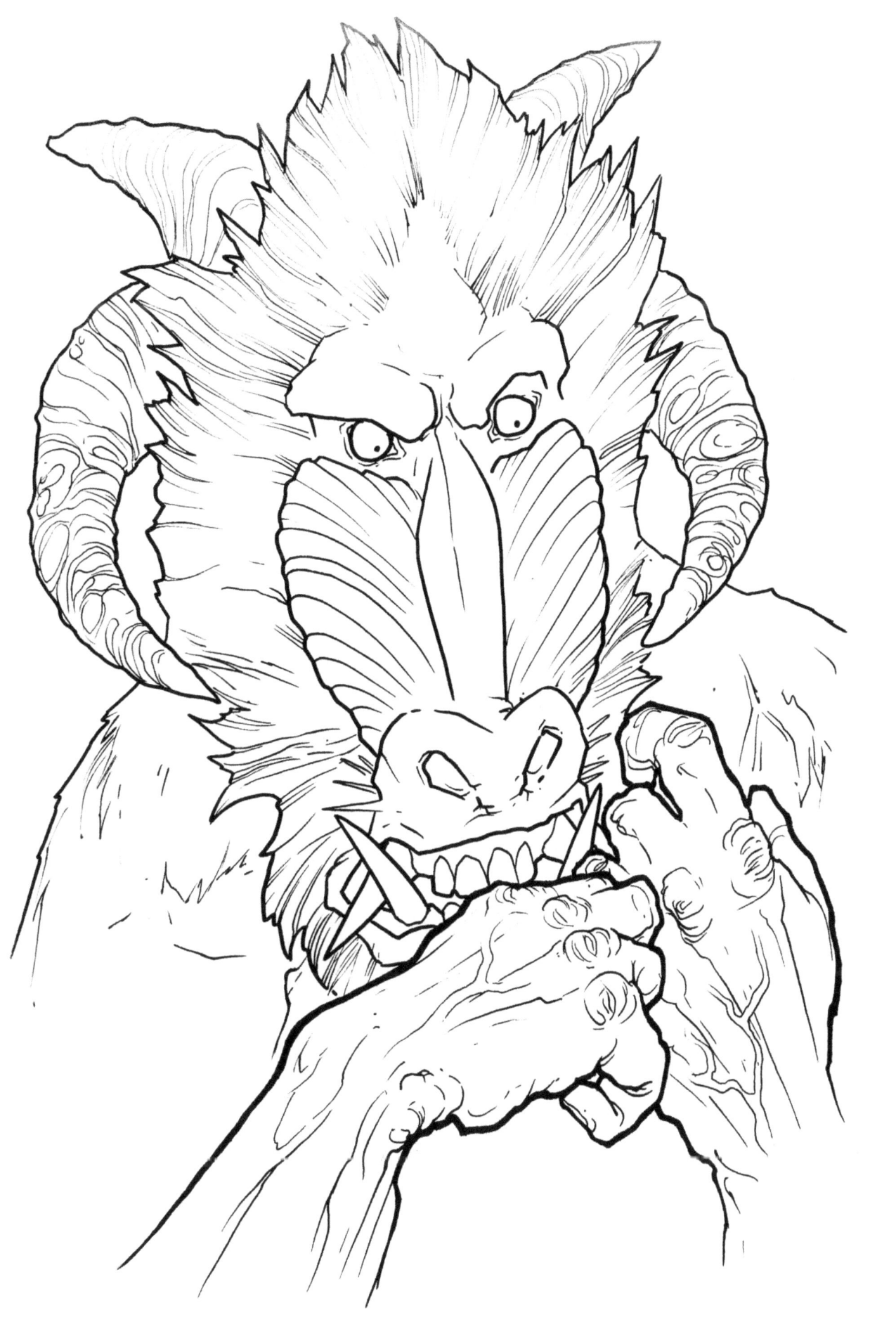

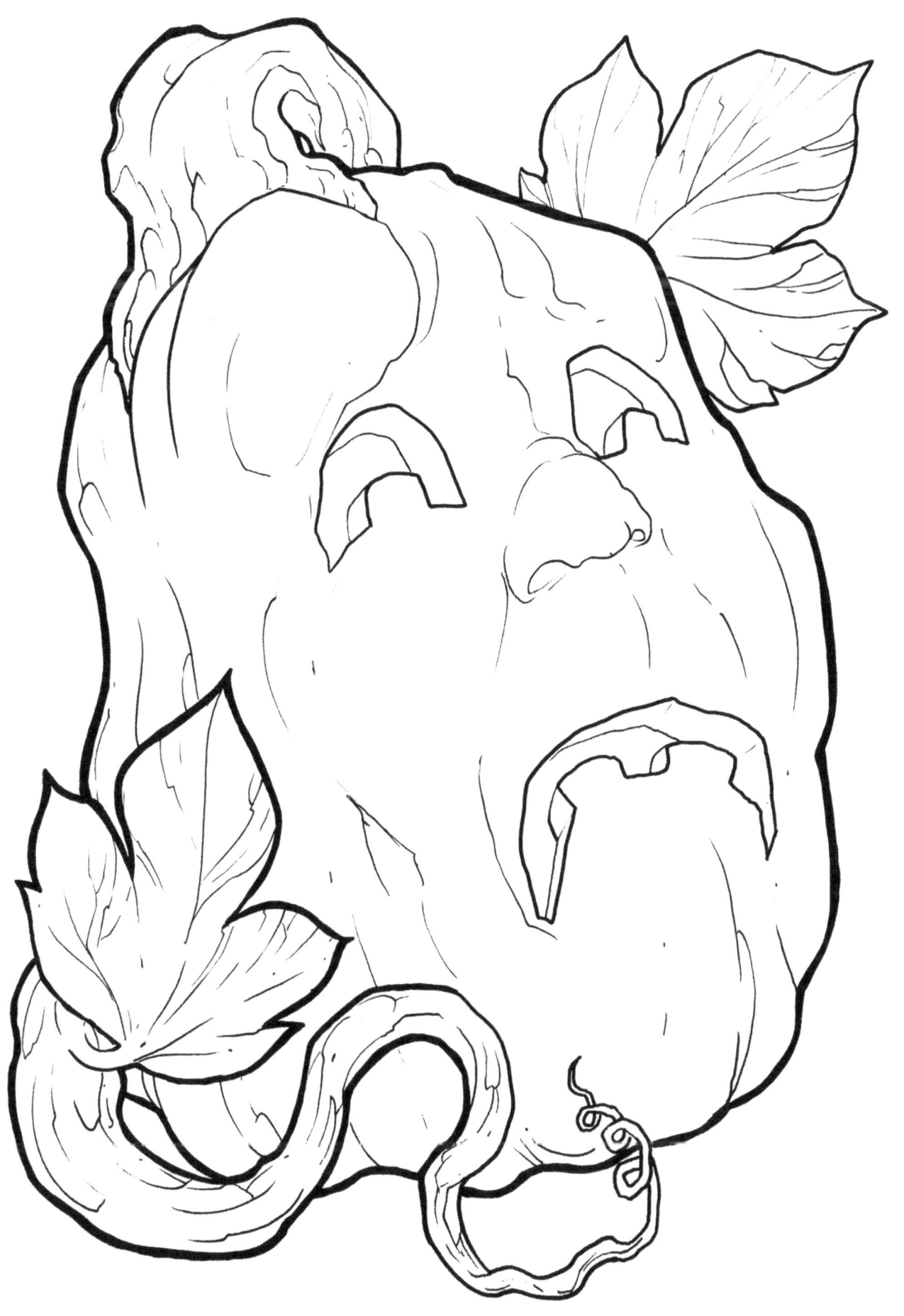

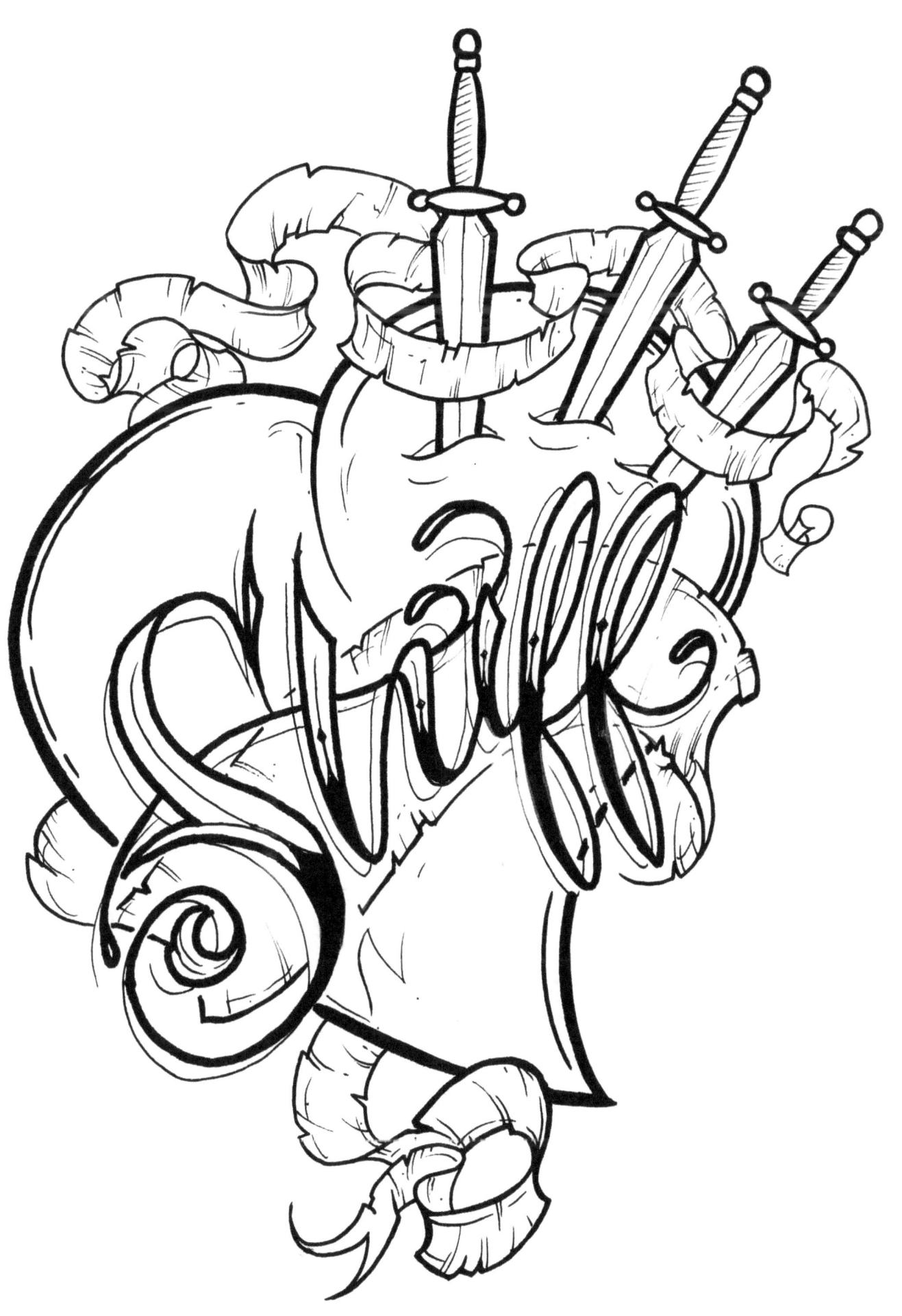

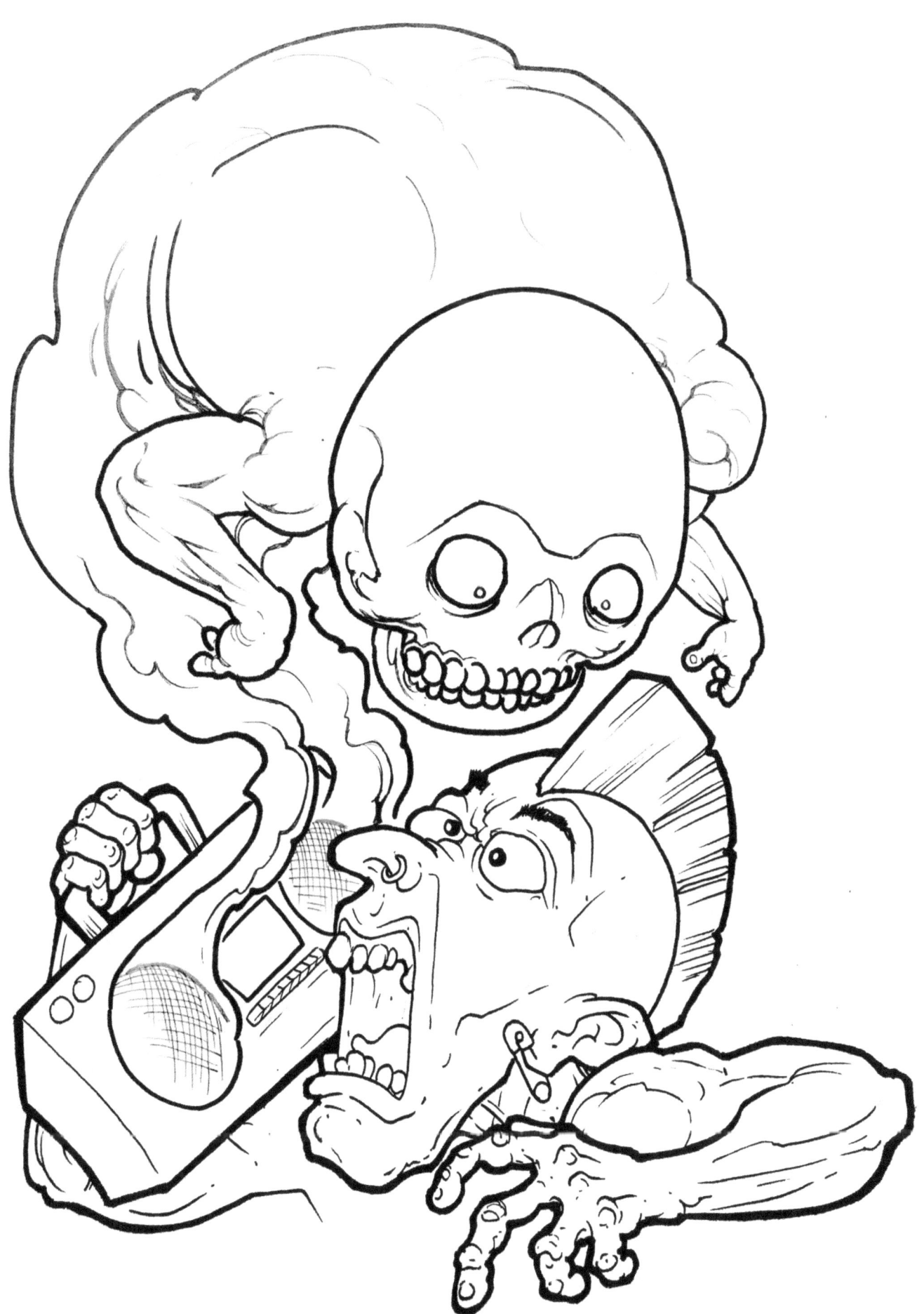

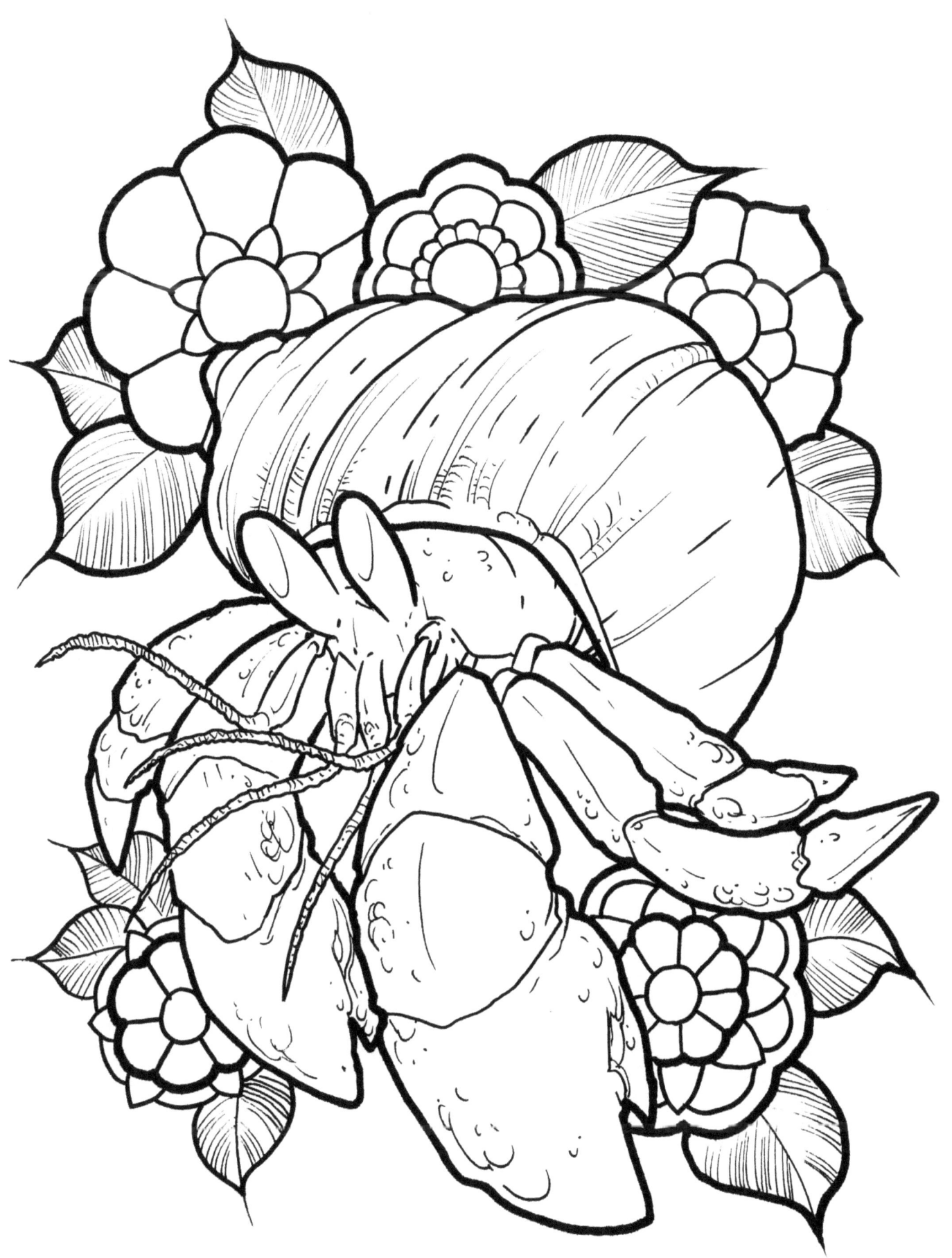

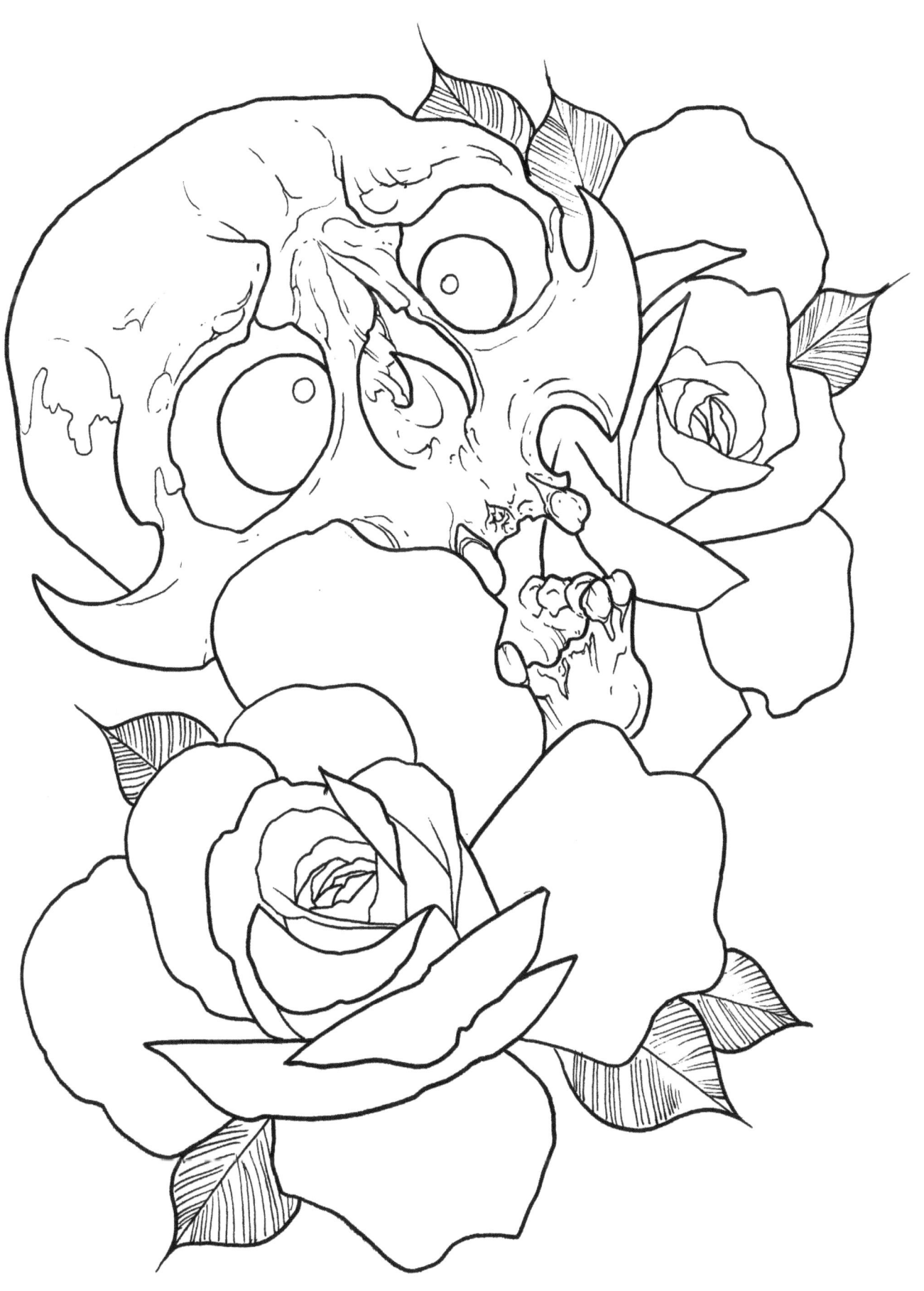

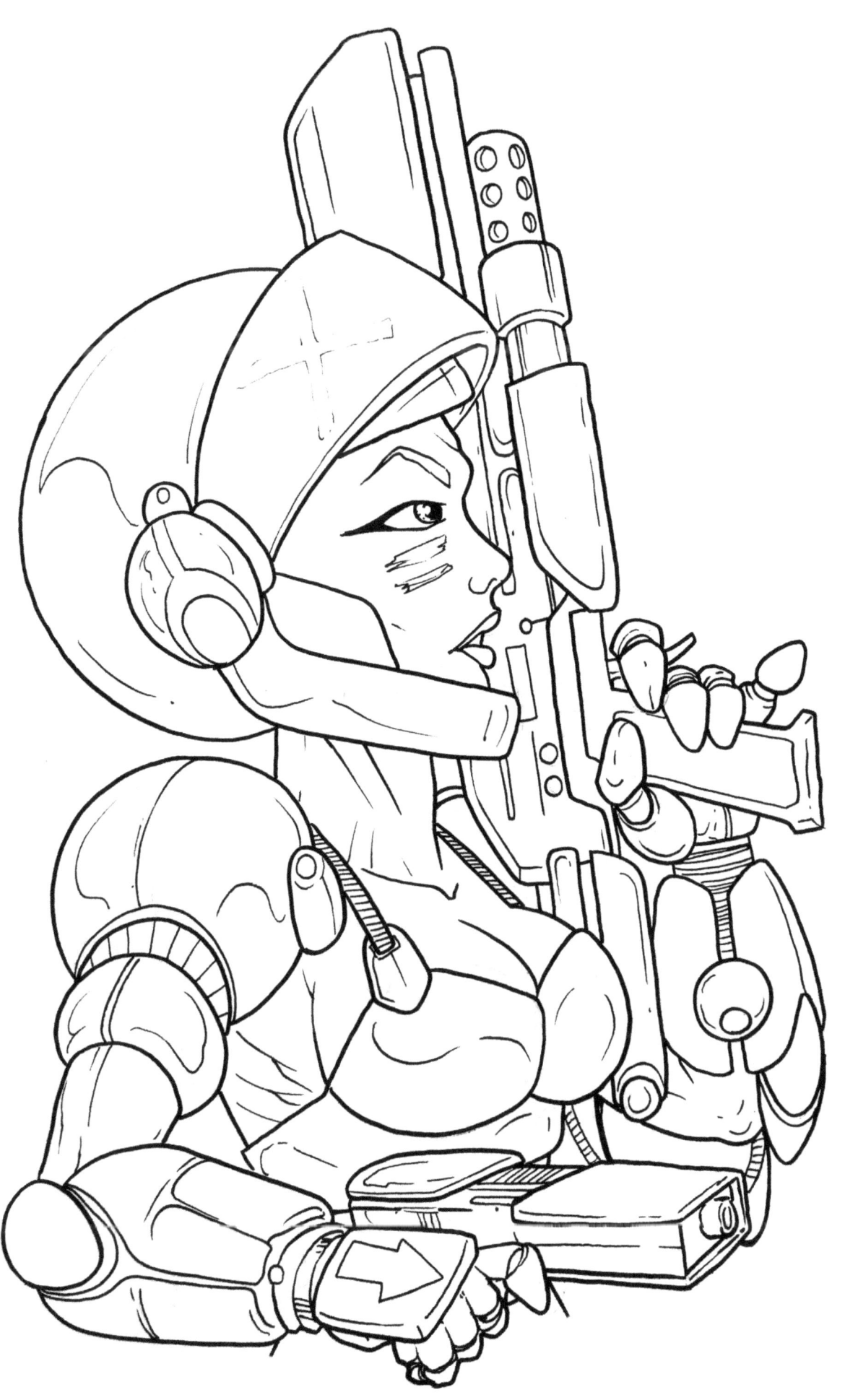

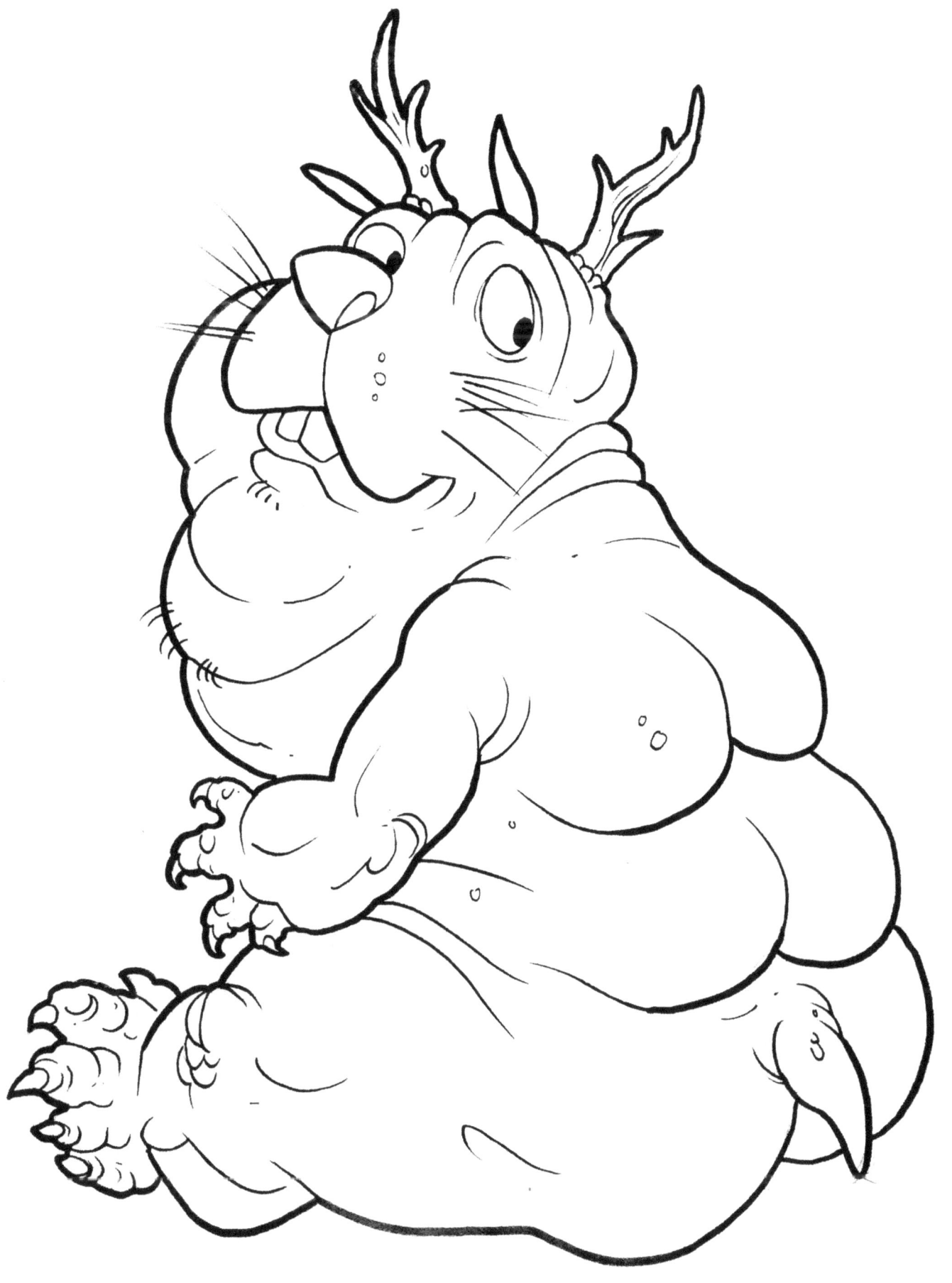

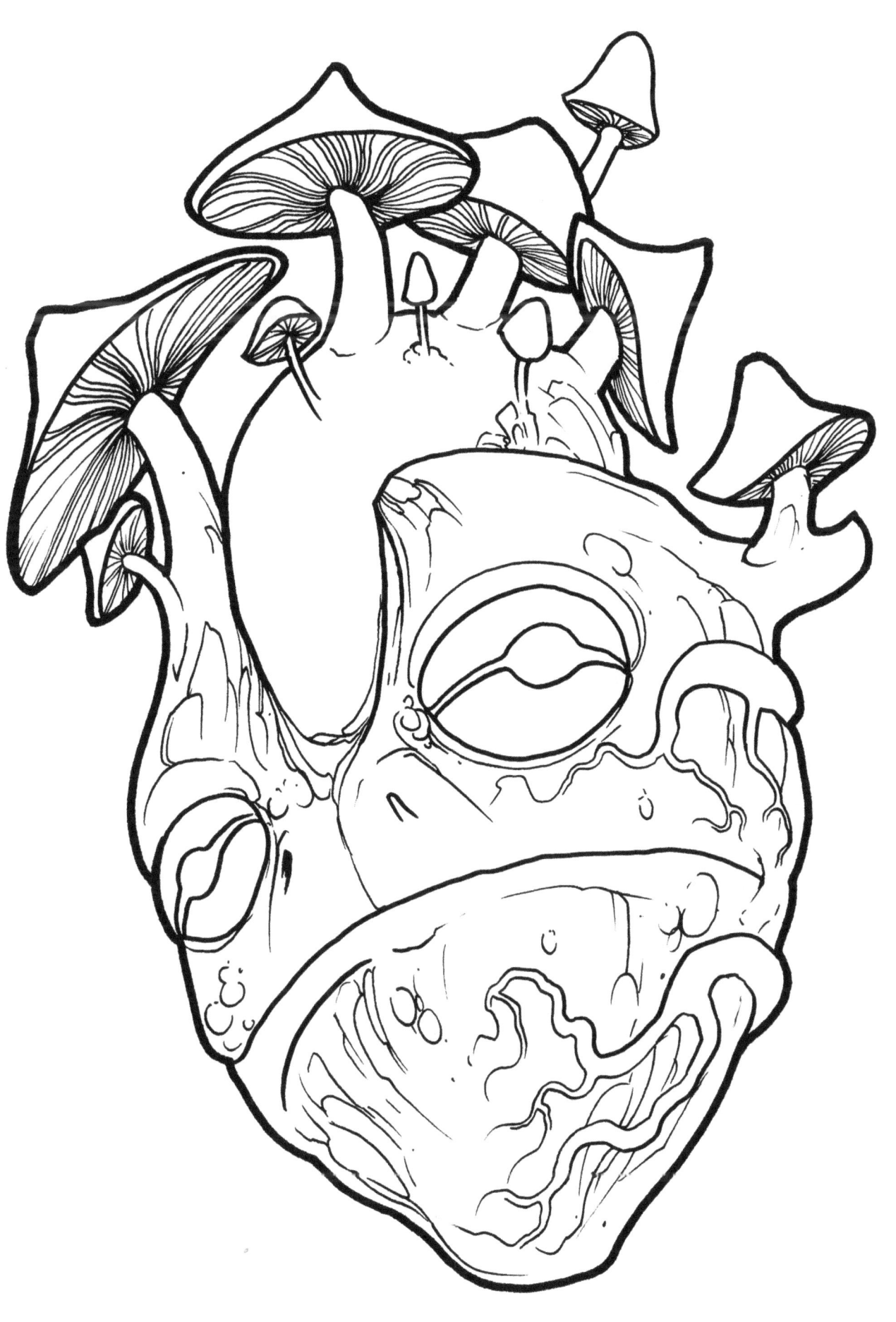

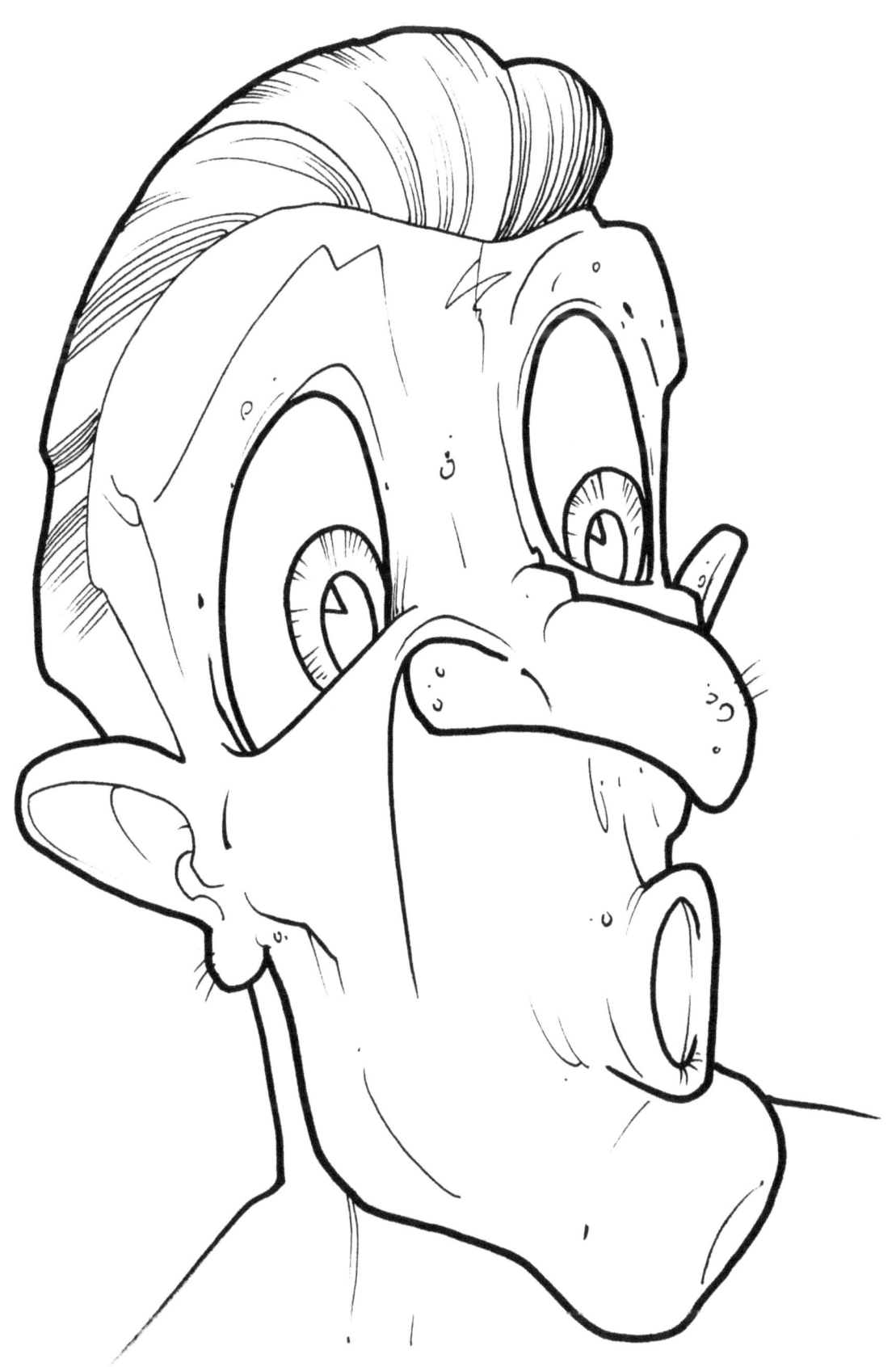

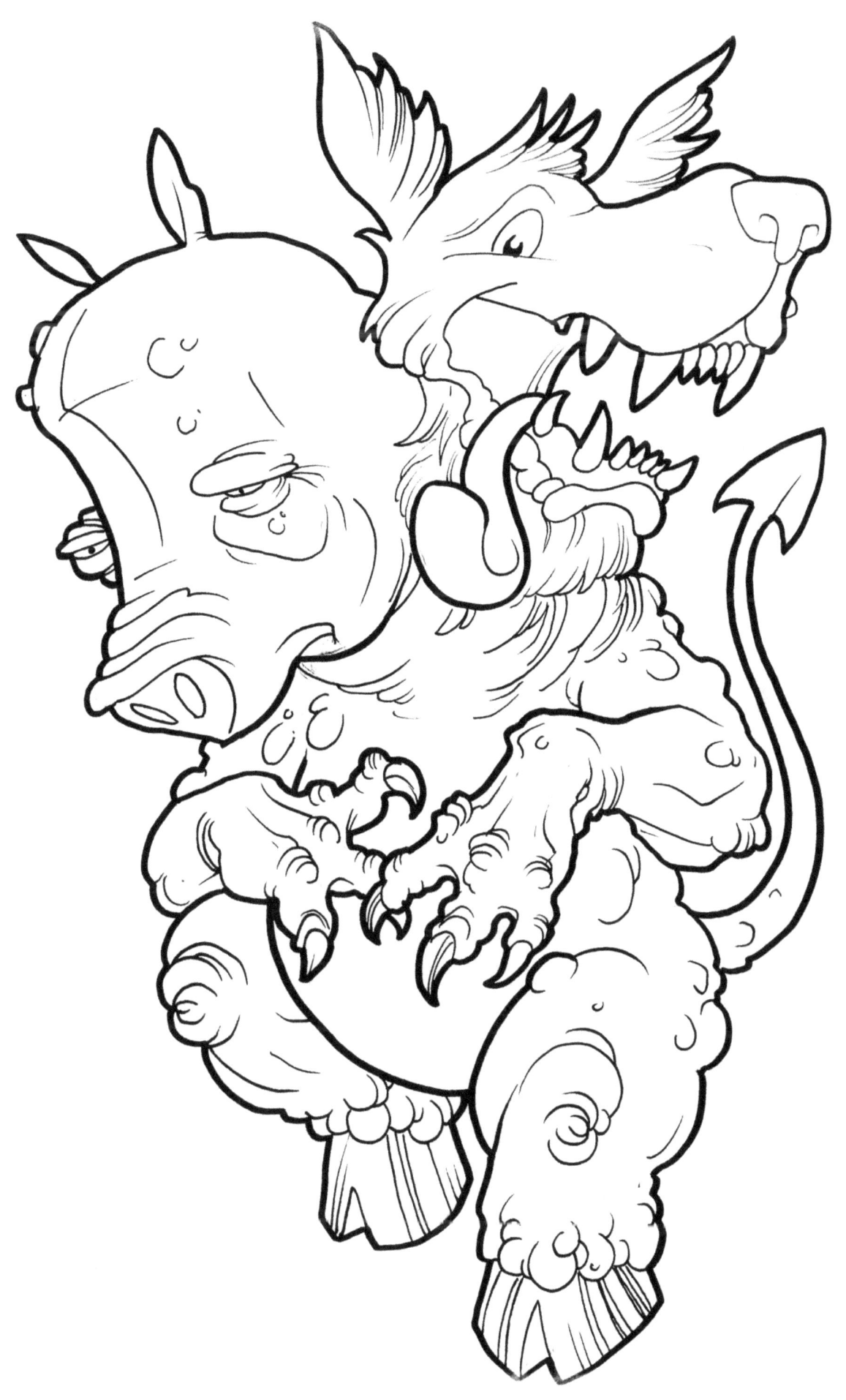

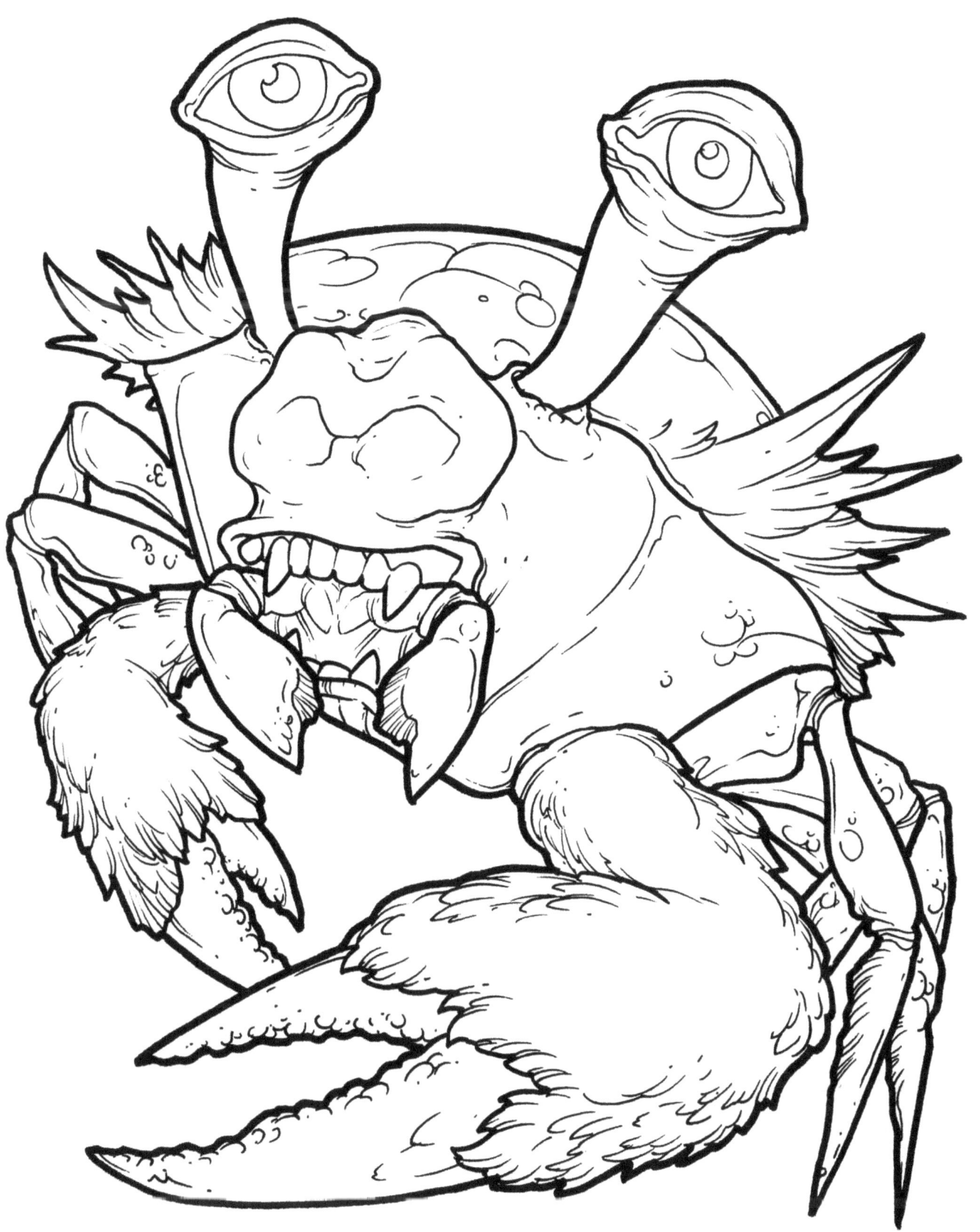

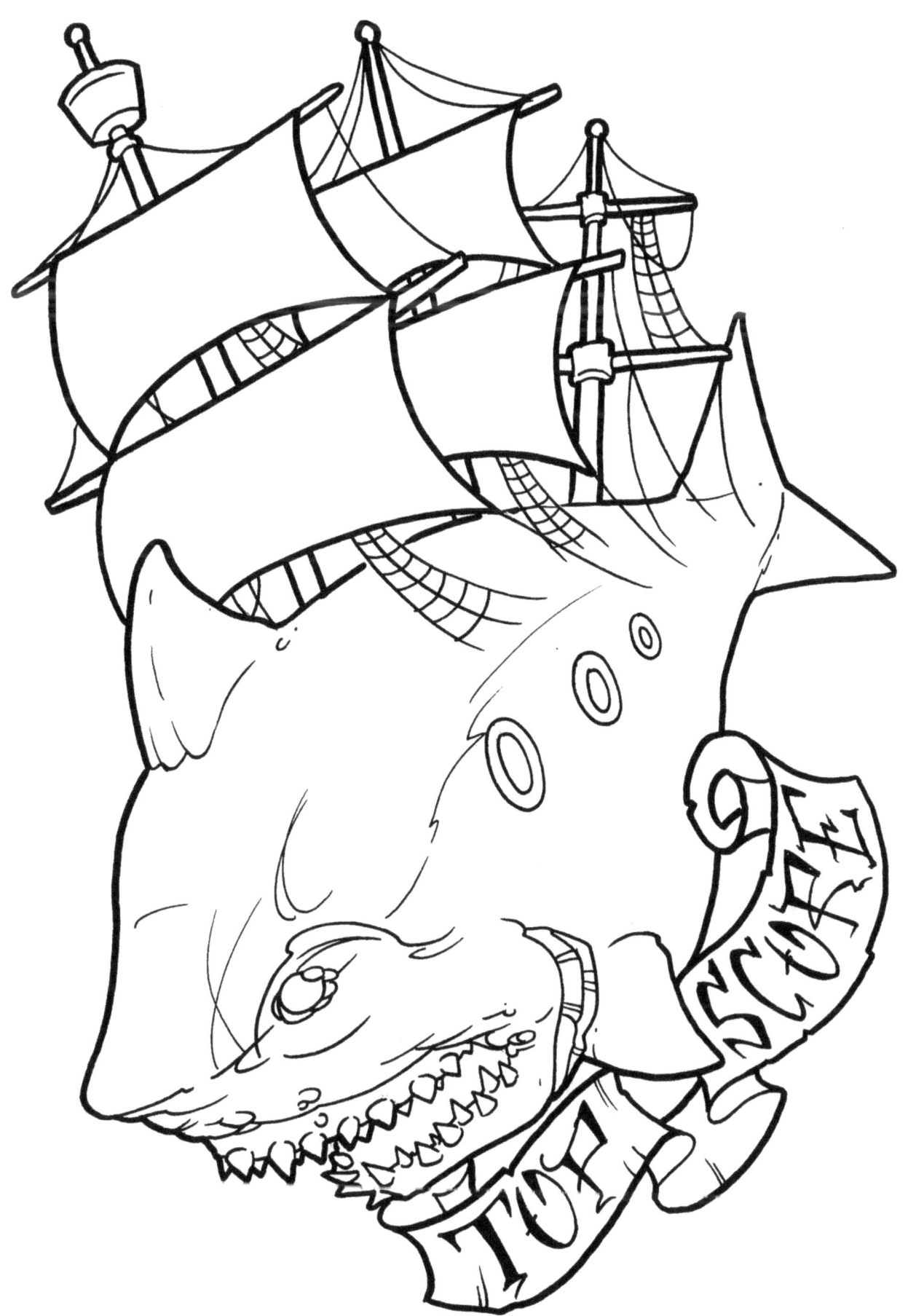

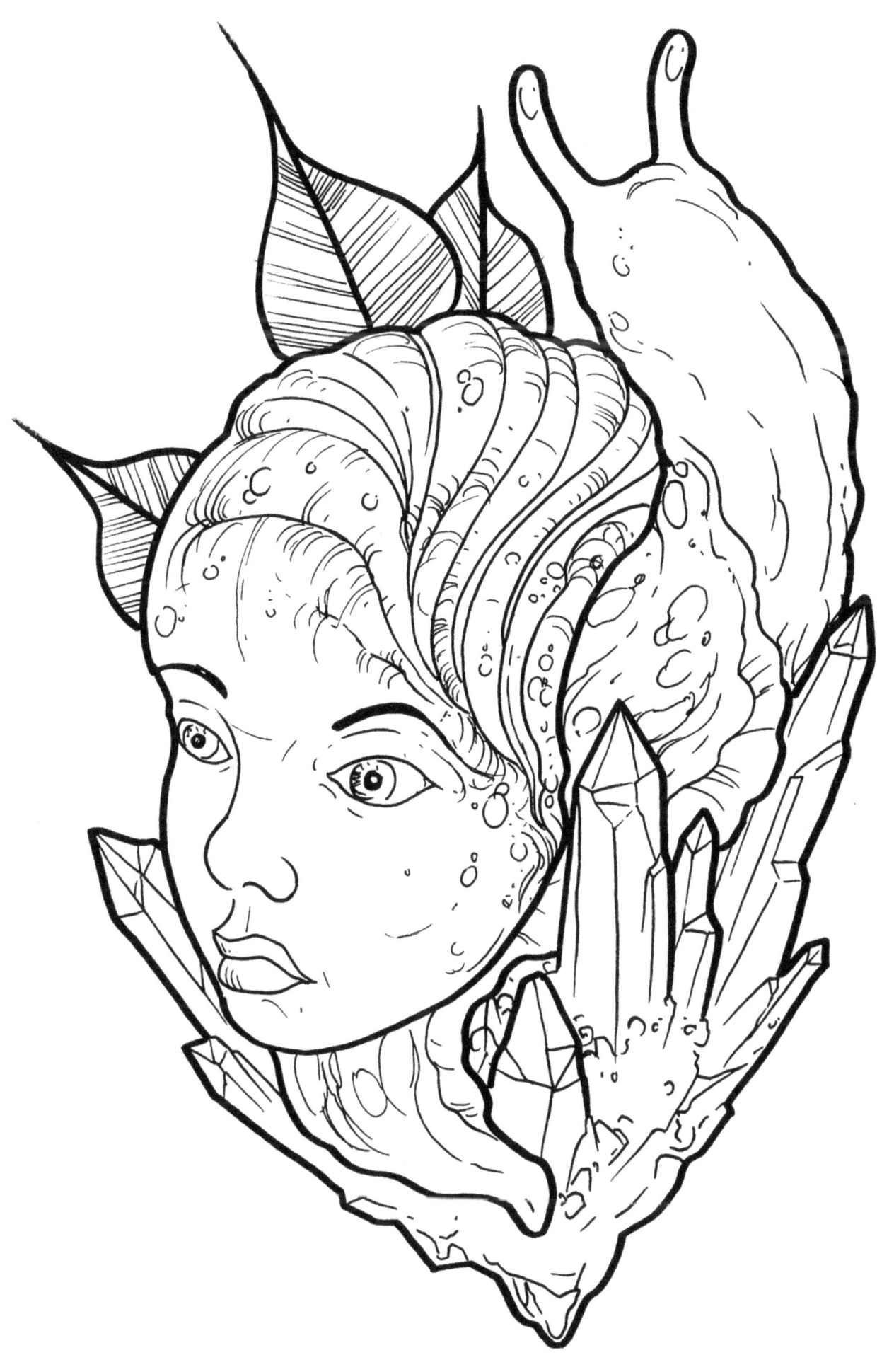

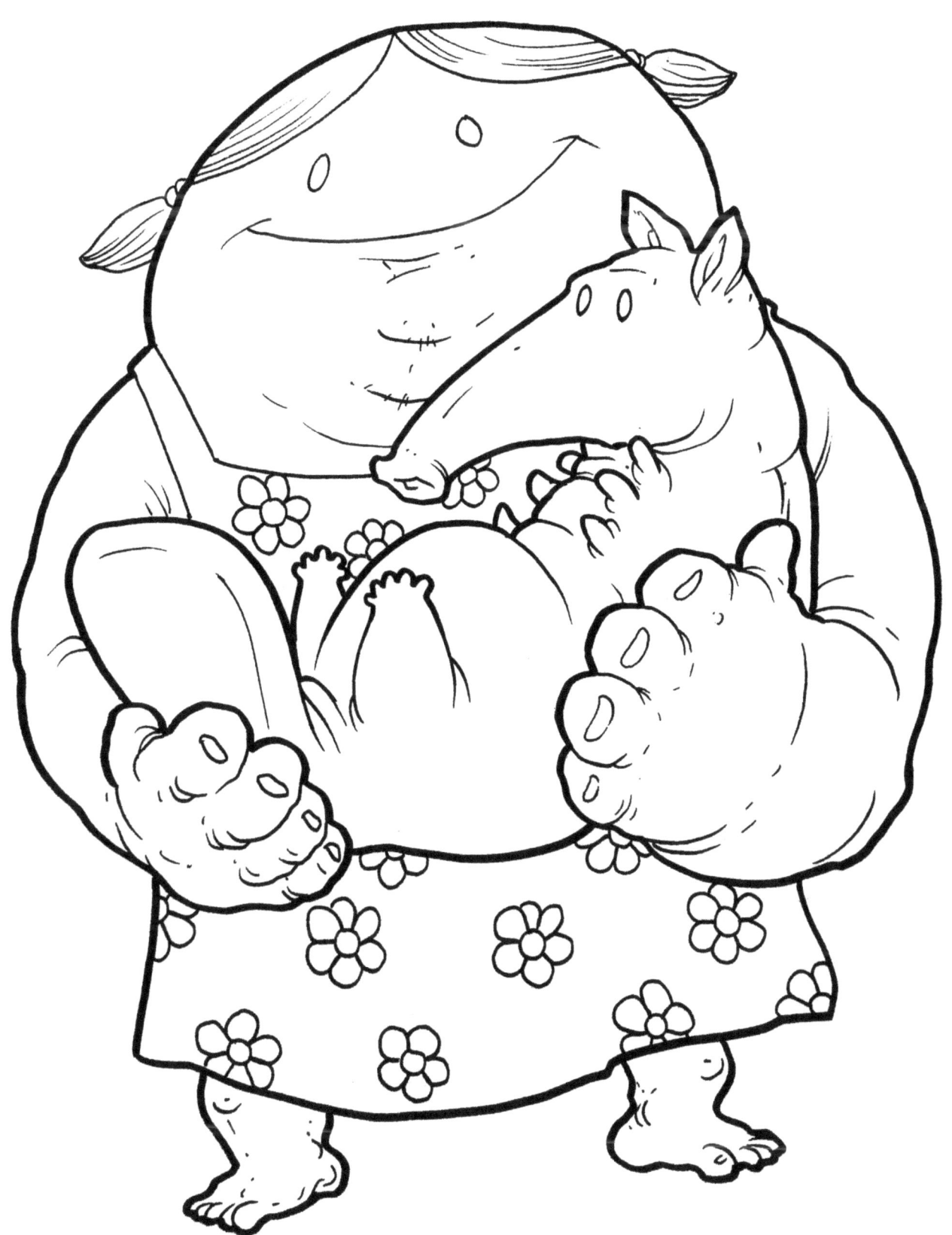

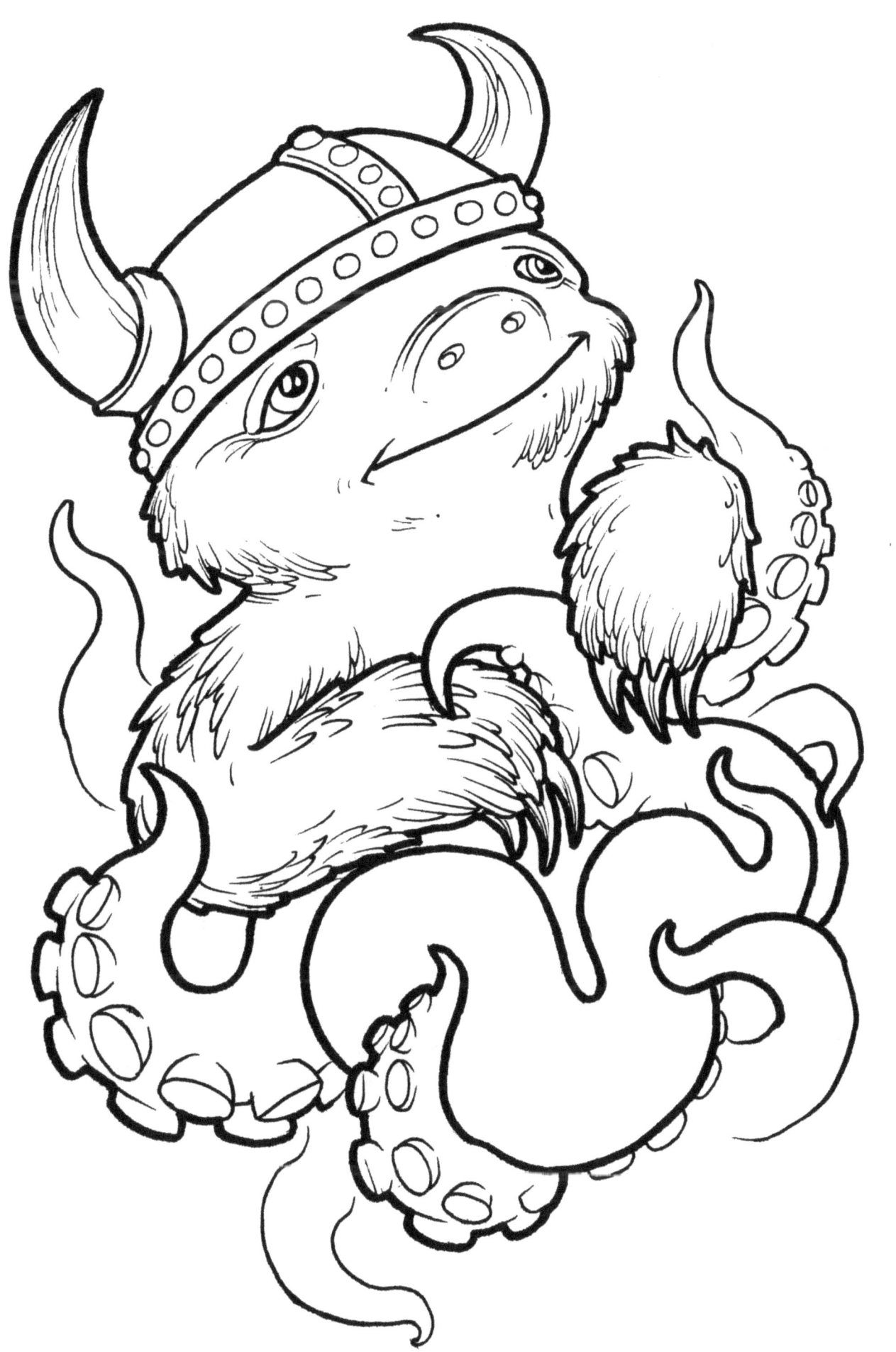

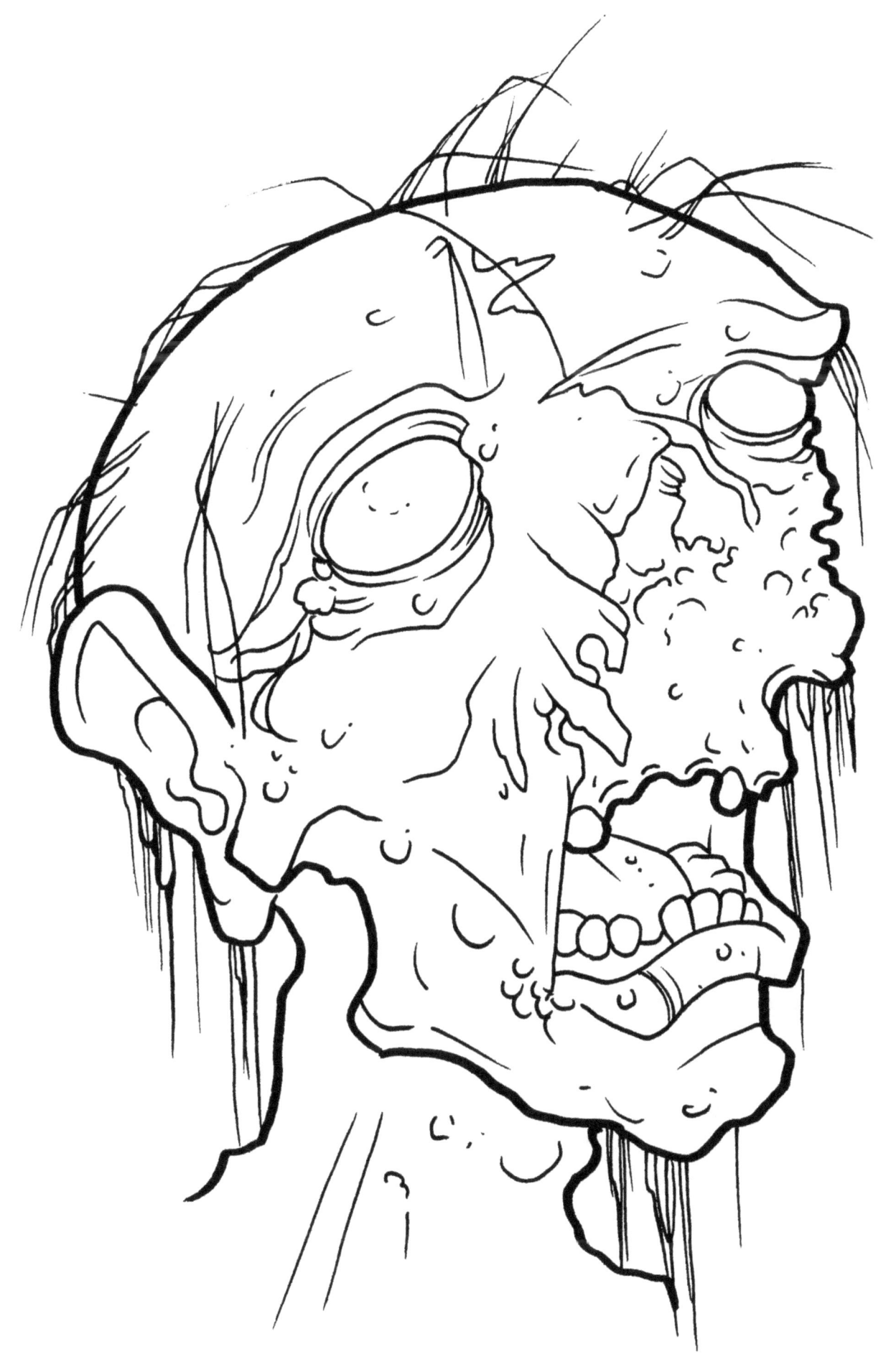

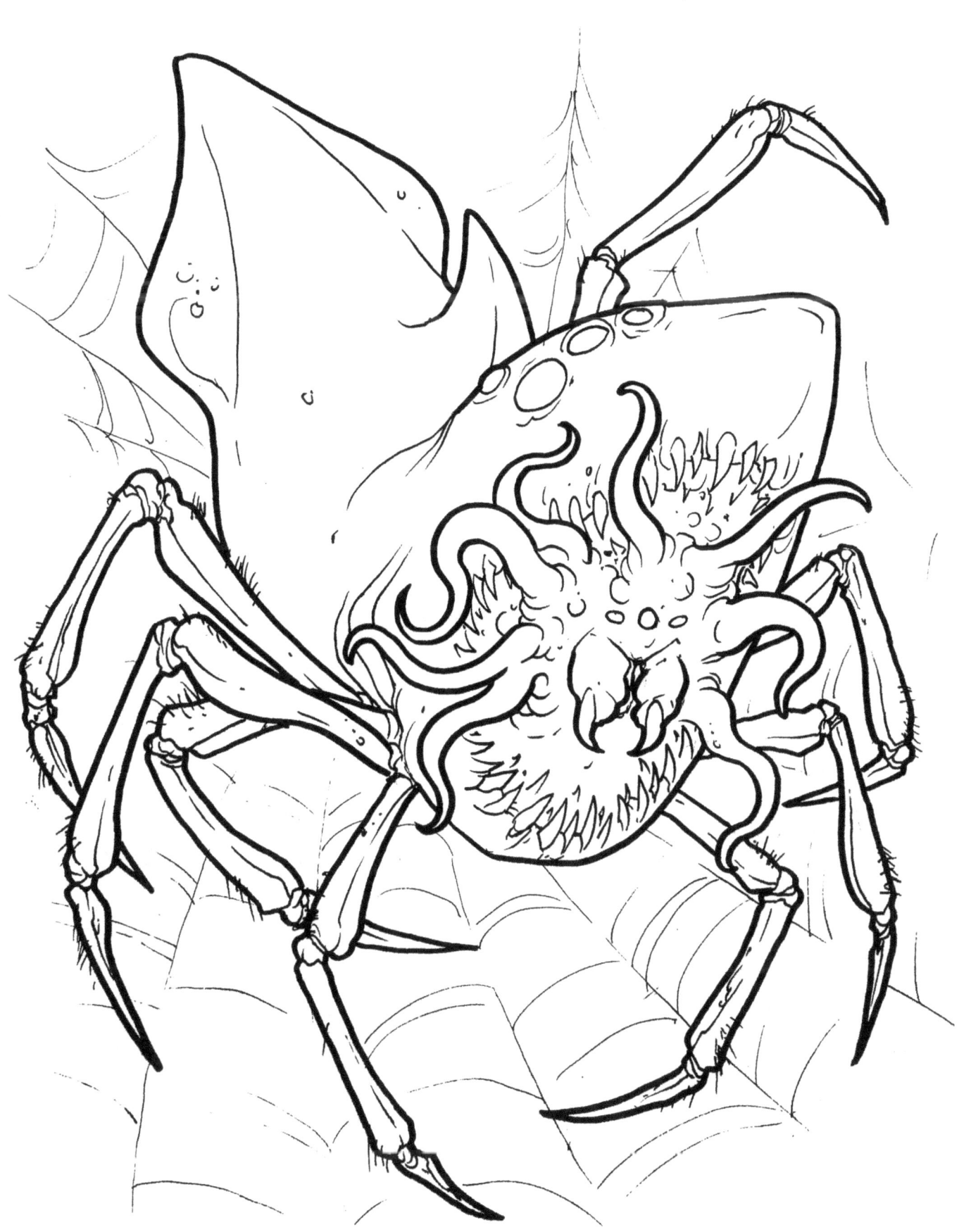

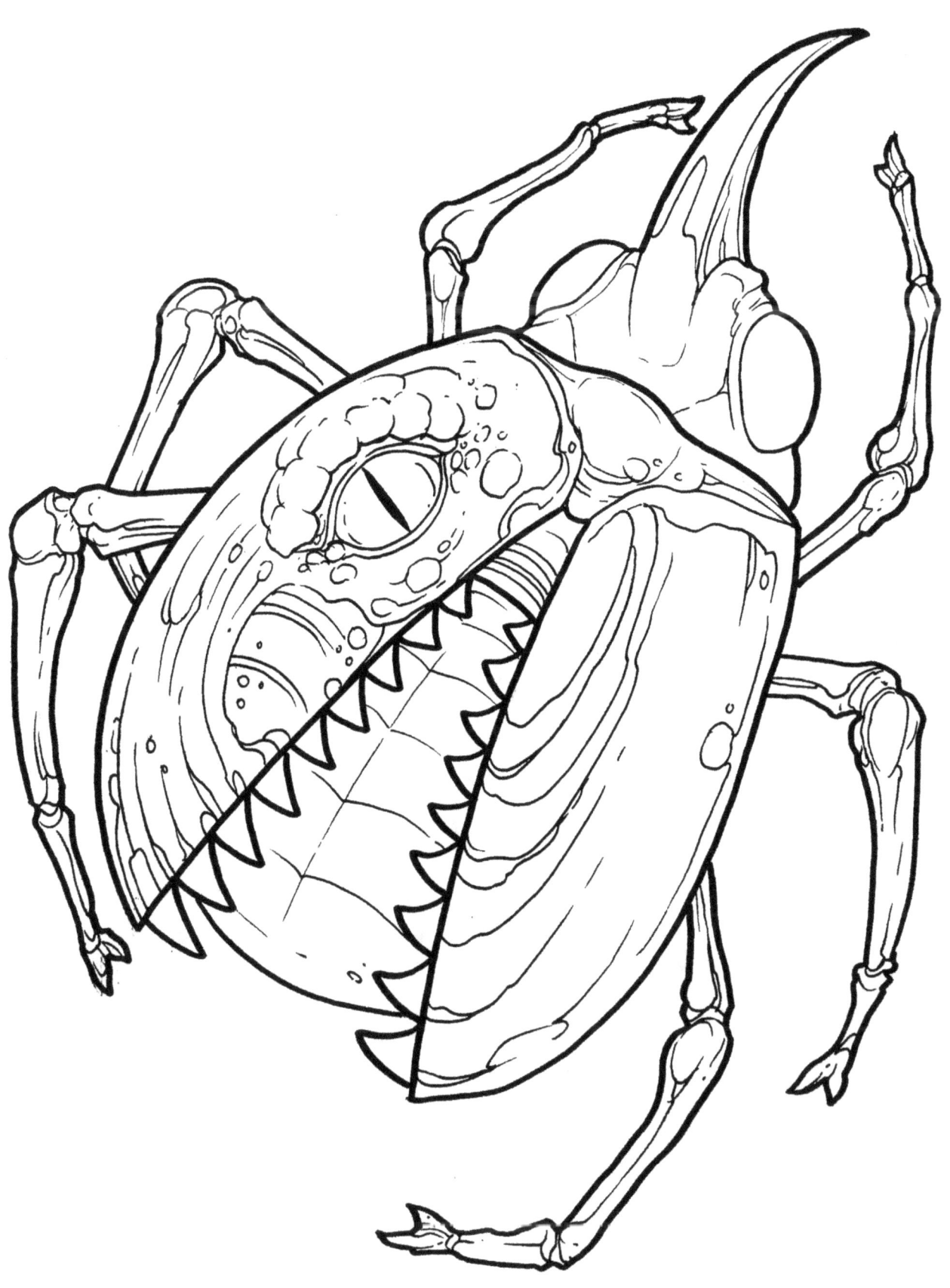

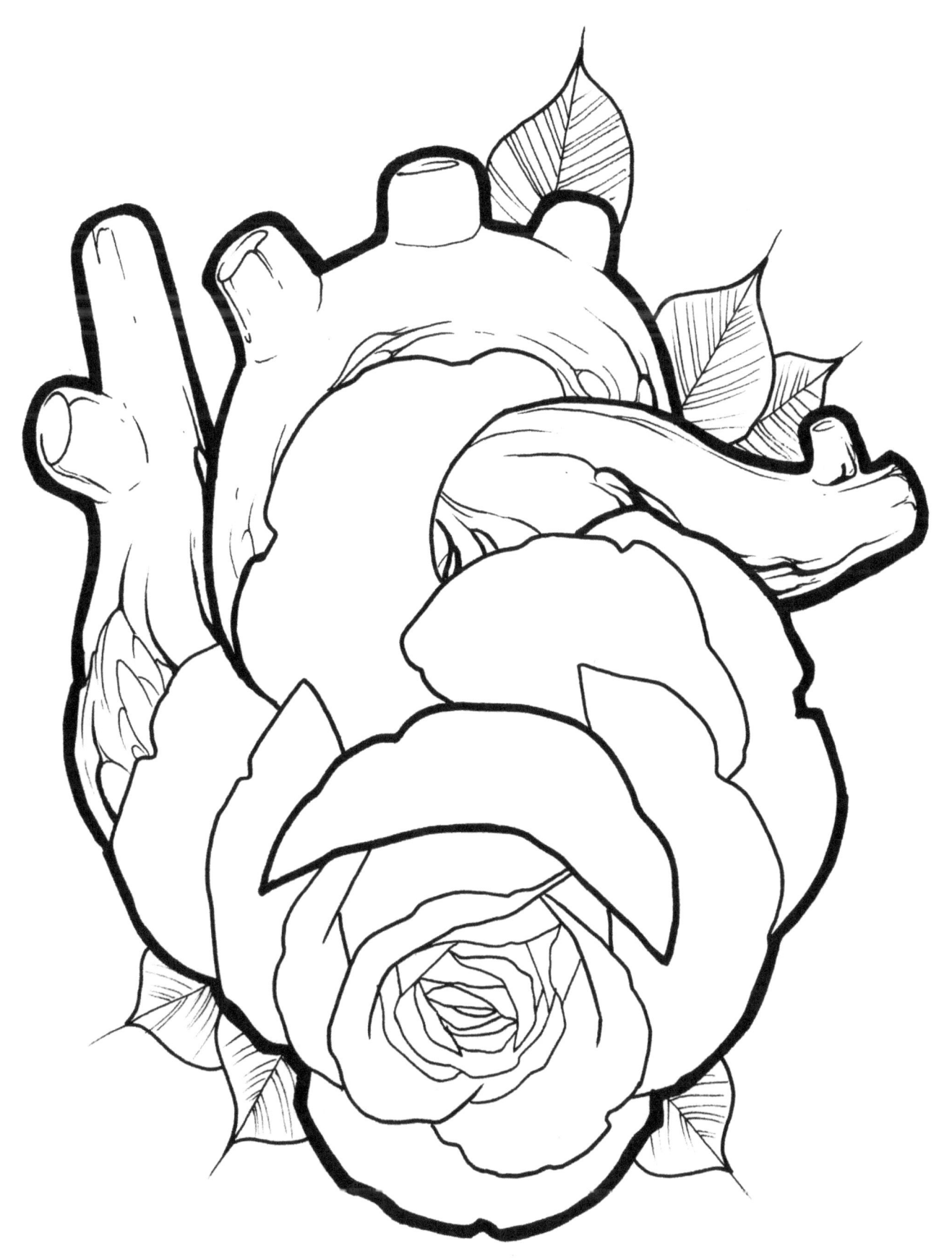

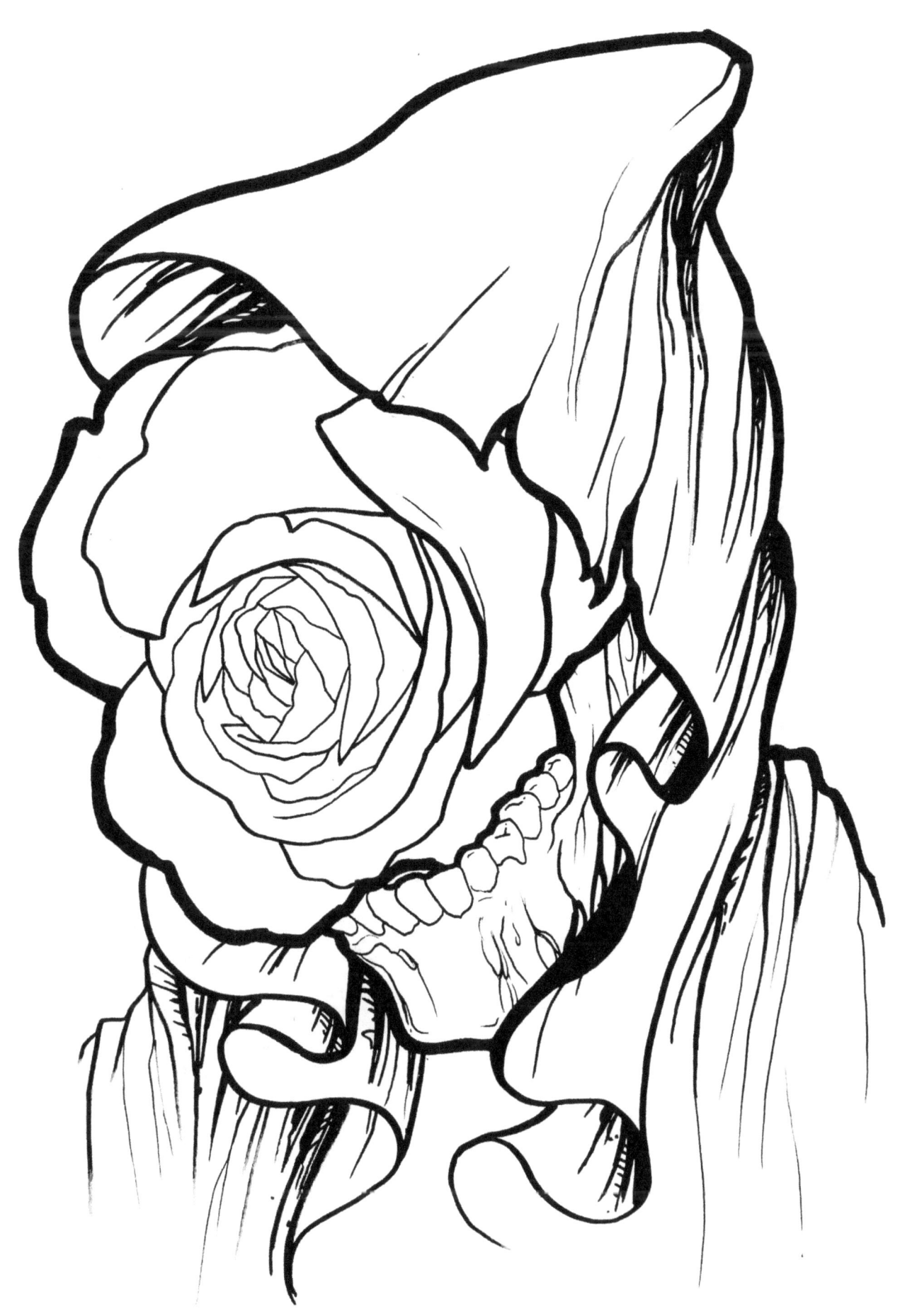

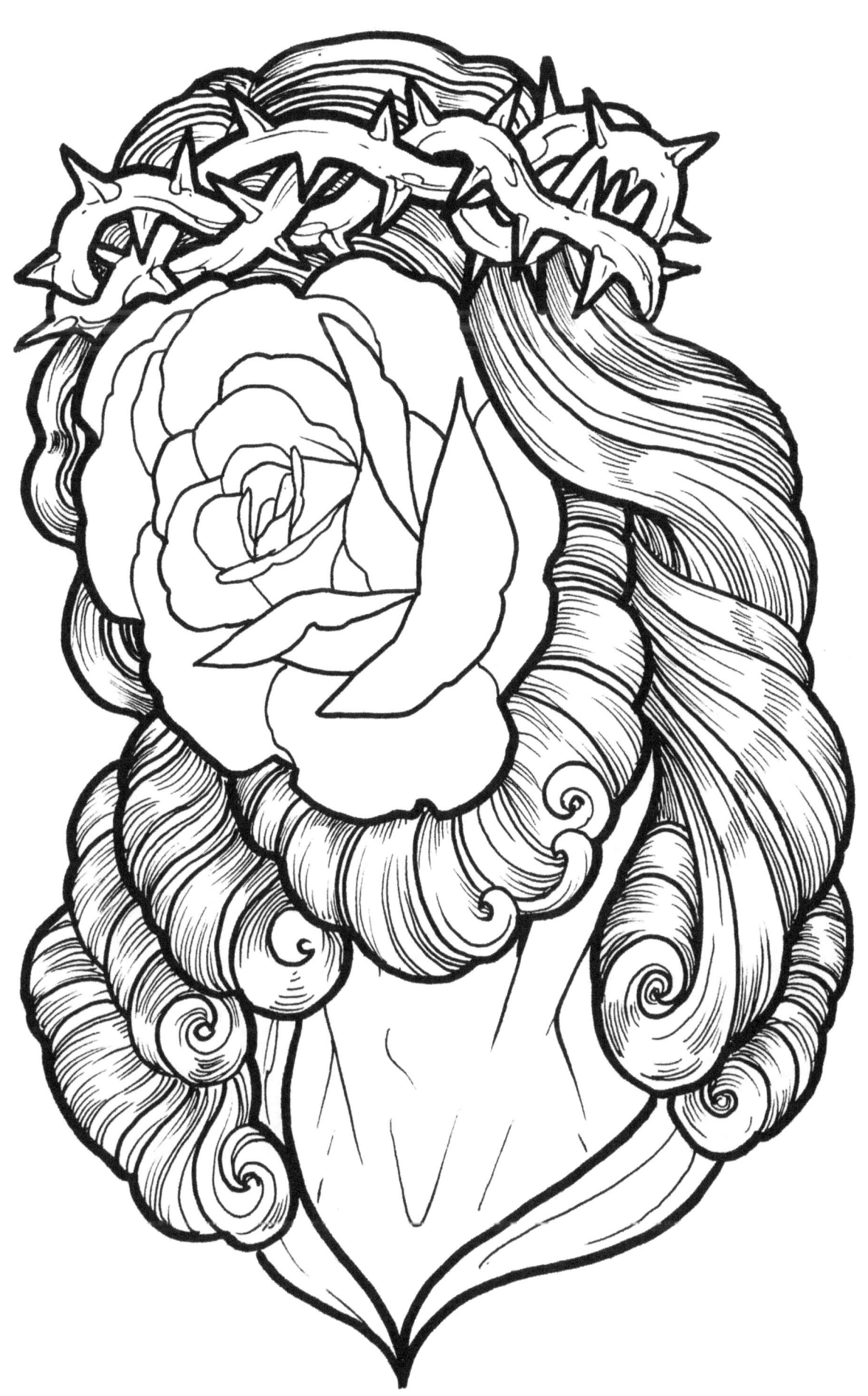

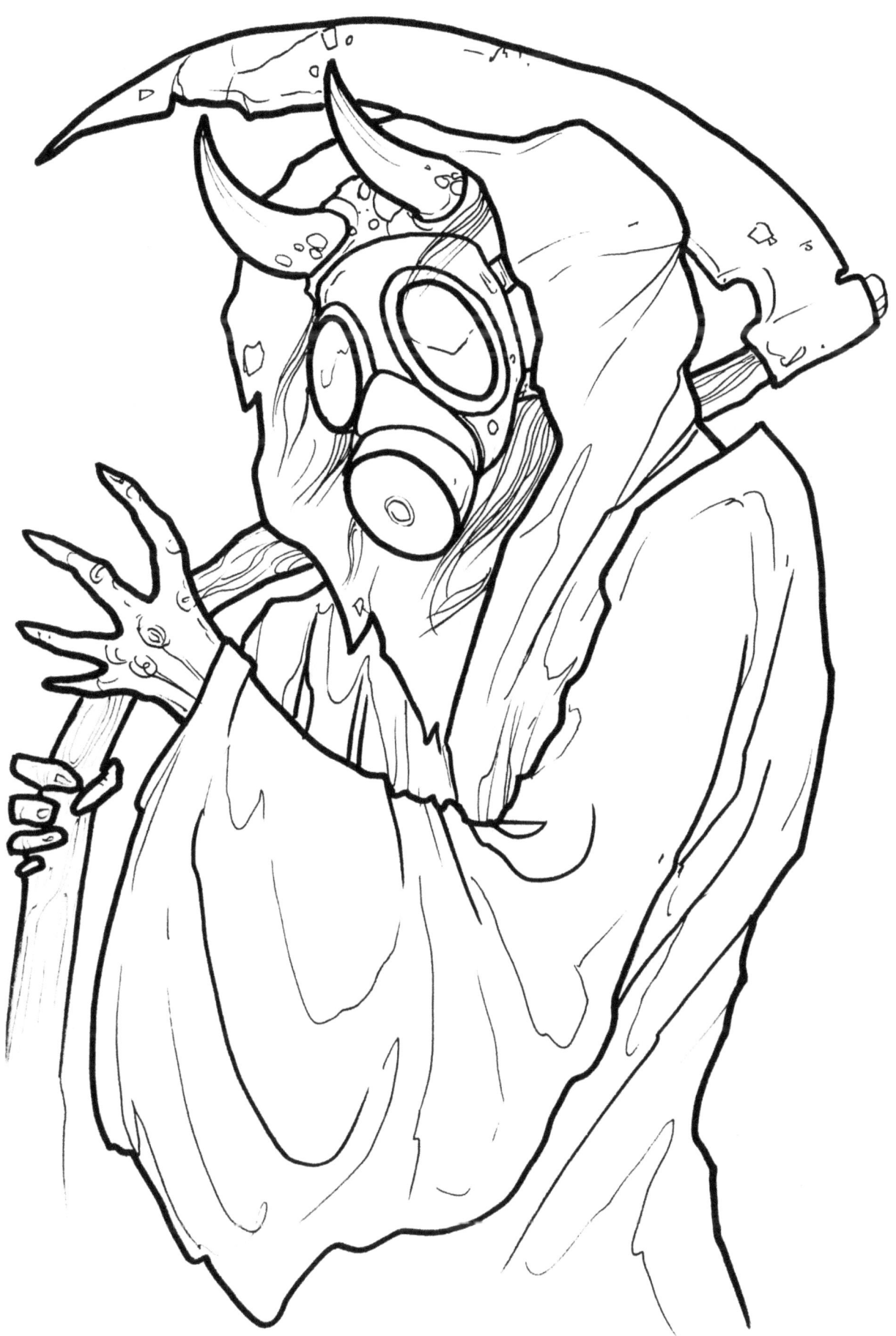

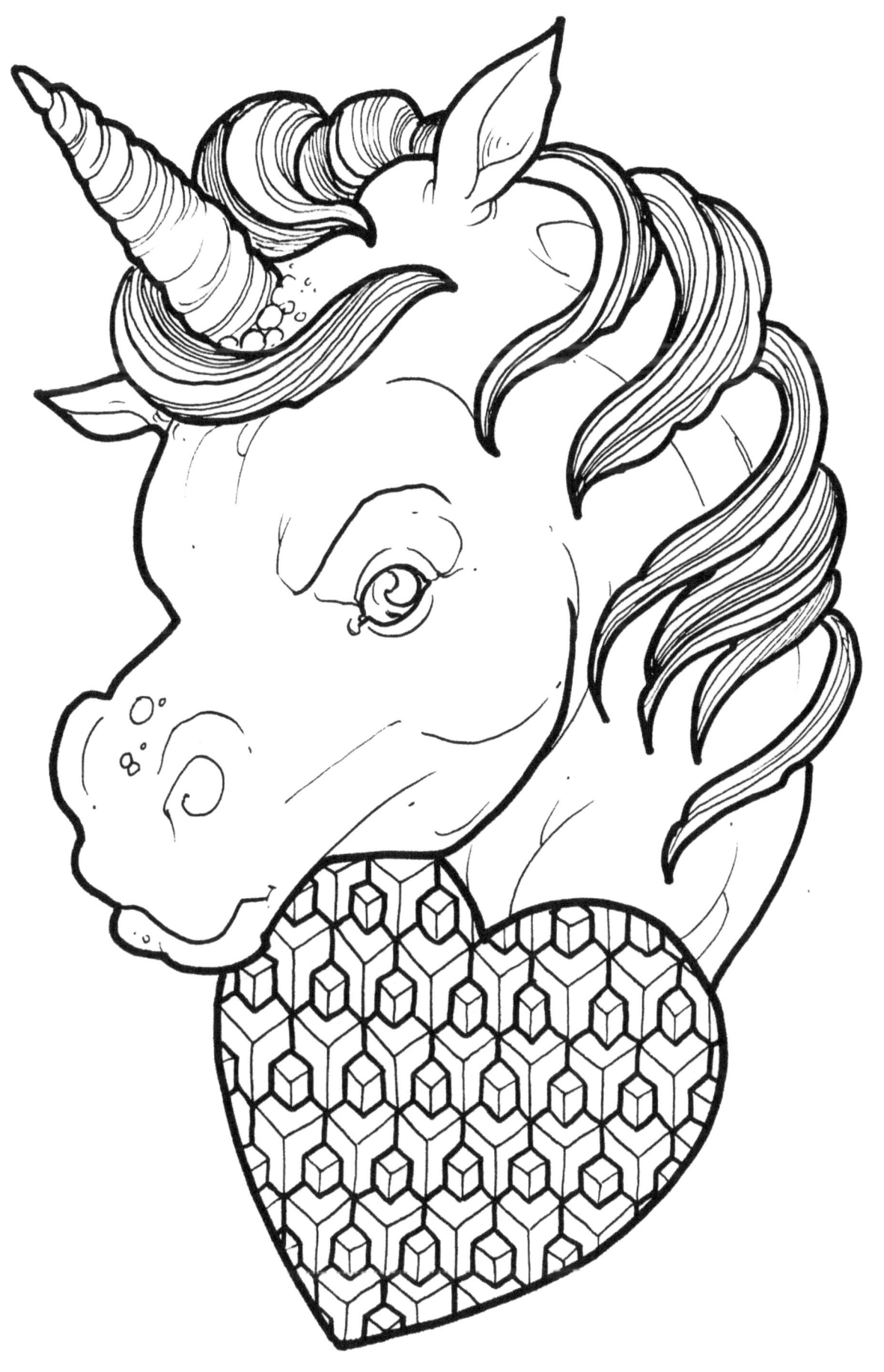

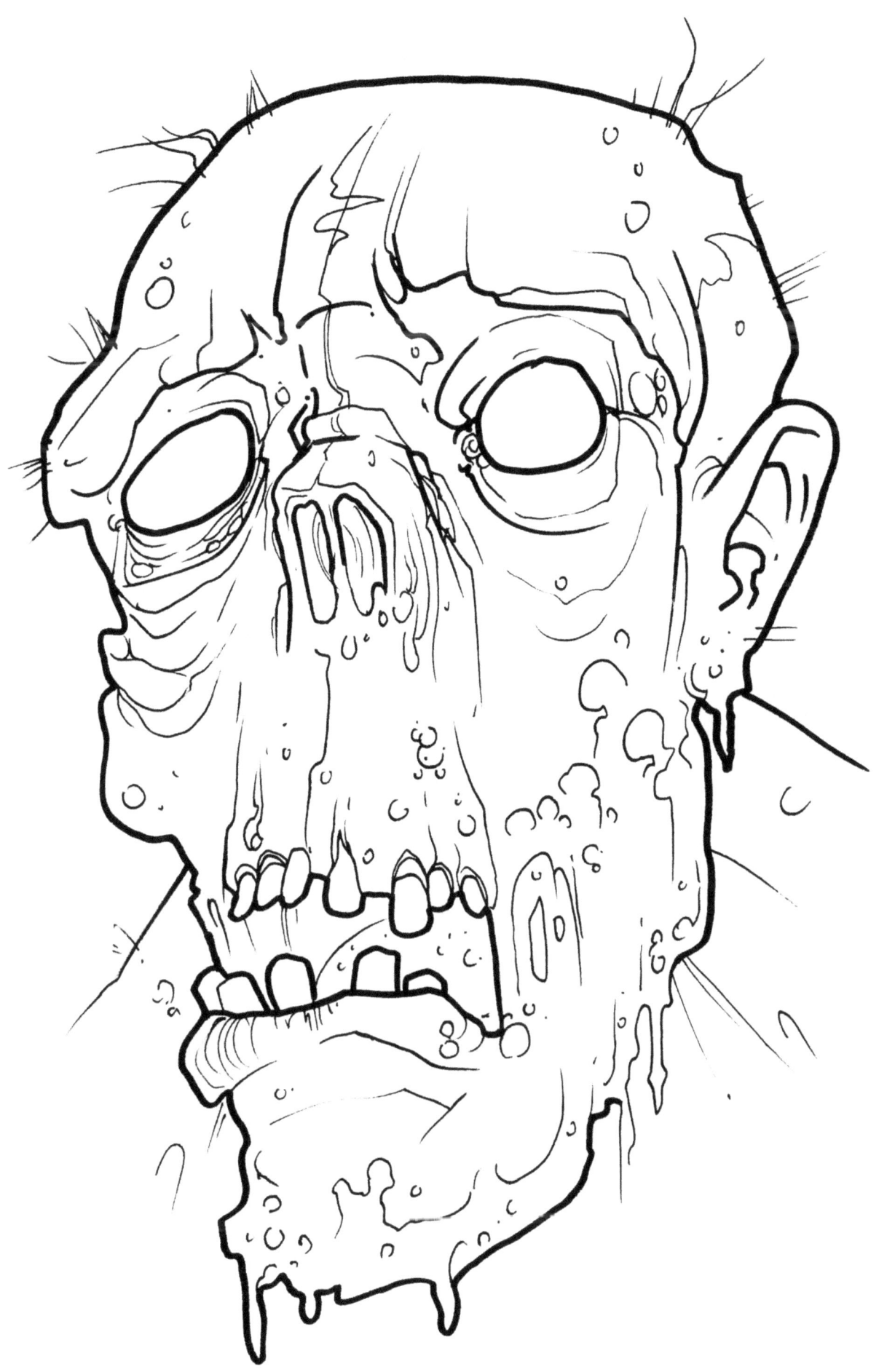

www.ingramcontent.com/pod-product-compliance
Lightning Source LLC
Chambersburg PA
CBHW080941170526
45158CB00008B/2335